W9-BPD-707

Casfiopeja.

Triangulum Majus.

Piscis.

Cancri.

Triangulum Minus.

Constellations

Reflections from life

SINÉAD GLEESON

Constellations
Reflections from life

PICADOR

First published 2019 by Picador
an imprint of Pan Macmillan
20 New Wharf Road, London N1 9RR
Associated companies throughout the world
www.panmacmillan.com

ISBN 978-1-5098-9273-0

3 5 7 9 8 6 4 2

A CIP catalogue record for this book is available from the British Library.

Typeset in 10.6/16 pt Janson Text LT Std by Jouve (UK), Milton Keynes
Printed and bound by CPI Group (UK) Ltd, Croydon, CRO 4YY

Visit **www.picador.com** to read more about all our books
and to buy them. You will also find features, author interviews and
news of any author events, and you can sign up for e-newsletters
so that you're always first to hear about our new releases.

To Steve,
For everything.

And in memory of Terry Gleeson.

Contents

'Censor the body and you censor breath and speech at the same time. Write yourself. Your body must be heard.'
— Hélène Cixous, *The Laugh of the Medusa*

'Empirically speaking, we are made of star stuff. Why aren't we talking more about that?'
— Maggie Nelson, *The Argonauts*

'I stood beneath the flag of motherhood and opened my mouth although I did not know the anthem'
— Liz Berry, *The Republic of Motherhood*

'Maybe the body is the only question an answer can't extinguish.'
— Ocean Vuong, from 'Immigrant Haibun',
Night Sky with Exit Wounds

Blue Hills and Chalk Bones

The Bullet Catch

The body is an afterthought. We don't stop to think of how the heart beats its steady rhythm; or watch our metatarsals fan out with every step. Unless it's involved in pleasure or pain, we pay this moving mass of vessel, blood and bone no mind. The lungs inflate, muscles contract, and there is no reason to assume they won't keep on doing so. Until one day, something changes: a corporeal blip. The body – its presence, its weight – is both an unignorable entity and routinely taken for granted. I started paying particular attention to mine in the months after turning thirteen. When a pain, persistent and new, began to slow me down. My body was sending panicked signals, but I could not figure out what they meant. The synovial fluid in my left hip began to evaporate like rain. The bones ground together, literally turning to dust. It happened quickly, an inverse magician's trick: now you *don't* see it, now you do. From basketball and sprinting to bone sore with a limp. Hospital stays became frequent, and I missed the first three months of school four years in a row.

Doctors tried everything to solve the mystery: firstly,

by applying 'slings and springs' – a jauntily named type of traction that sounded to me like a clown duo. Then surgery. Biopsies. An aspiration: a name that suggests hopefulness, but yielded no results. My godmother Terry visited daily, bringing dinners and soft toys she'd won in claw-crane machines, while my bones continued to disintegrate.

The eventual diagnosis was monoarticular arthritis. Doctors mentioned an operation called an arthrodesis, which, even in the late 1980s, they were reluctant to perform. 'Especially on girls,' the surgeon told my parents amid much throat clearing, but I didn't discover what he meant until years later. That I would have years of wishing my body could do things it couldn't do, and explaining myself to others.

Numbers and Rituals

In the Bible, there is a story in Genesis of Jacob wrestling with a stranger, thought to be an angel. When the angel couldn't defeat him, he touched Jacob's hip, dislocating it, leaving him with a limp for life. Jacob was circumspect, viewing it as a reminder of his mortality, of the fact that the angel spared his life. That the spiritual self is more powerful than the physical body.

I was a pious child. Weekly Mass, regular trips to confession, and above all a fervent and deeply held belief in God, heaven and all the saints. This was reinforced by heavy indoctrination at school. In the local church, I bought books of religious poetry from a friend of my grandmother,

who had a stall near the confession box. The poems were stanzas about nature; predictable rhymes steeped in Pantheism. The covers were always of fields, skies and flowers. Real majesty of the Lord stuff – but I coveted these books with their small folio and cheap binding.

In the late 1980s, Ireland's Catholicism had not yet unravelled. Priests still inspired fear in their congregations, but it was long before it was discovered that some of them had been raping children. A very specific kind of mistreatment was meted out to women. Contraception had been illegal until 1979, and then available on prescription. Being difficult to obtain made crisis pregnancies common. Until the 1960s, a married woman might be permanently pregnant: eight, ten, twelve pregnancies were not unusual. I hear it as one word – 'eighttentwelve' – as though the numbers don't matter. As though double-figure pregnancies were to be stoically endured, like flu or a headache. Friends of my mother went to England and brought back suitcases full of condoms to pass around like war rations.

When my older brother was born in 1970, my mother had to be 'churched' before she was allowed to return to Mass. The priest blessed all new mothers, cleansing them of impurity for having had a baby. In the eyes of holy men, even giving birth tainted women's bodies. It was not until 2018 that Ireland held a referendum on abortion, and passed a limited law for terminations in certain cases of up to twelve weeks.

Rope Lanes

The first hospital stay is three weeks long, followed by various types of physiotherapy: outpatient appointments and mandatory daily swimming. For three months in winter my mother drove me to a pool daily. We both got bored of the cold, and the same blueness; of me swimming lengths of front crawl and breaststroke over mosaic tiles. Days became weeks, and I propelled myself through lanes of lukewarm chlorine without incident. Until one night a group of rowdy teenage boys slammed into me, a foot knifing into my hip. The unexpected pain had the effect of a power cut. My body stopped, my brain tried to figure out what had happened. No flailing, just stillness. I stared into the chlorine blur and wondered if the joint was damaged, sinking until a lifeguard dove in and fished me out.

My grandmother used to work at another local pool, and convinced her old colleagues to let me swim there when it was closed. Alone, with the underwater lights, its tiled bowl felt eerie. All that blue, and quiet, the water shadows on the ceiling. I scared myself by imagining what lay beneath. Each week, I swam faster and got stronger. My body became an inverse: strong arms, while the weak left leg refused to move or build muscle. It withered, and is still thinner than the right. My lack of symmetry endures.

1988

In 1988, Dublin is a thousand years old, and the city celebrates with parades and commemorative milk bottles. The focus-grouped slogan for the year is 'Dublin's Great in '88'.

In 1988, I am thirteen, and Ray Houghton scores for Ireland against England in the European Football Championship. Headscarfed women like my grandmother light candles in churches in the hope we'll beat the Soviet Union (we draw) and the Netherlands (we lose).

In 1988, my mother brings me to an old redbrick house near Dublin's South Circular Road. The woman who lives there owns a small glass relic of Padre Pio, containing some of his bone. My hip and the bones of a Catholic saint are briefly united as she rubs it over my hip with a susurration of prayers. Although nothing happens in the weeks that follow, my faith stays strong. I develop a habit of dipping my fingers in the holy water font at Mass and flicking a few drops in the general direction of my pelvis.

In 1988, my school announces a trip to France. A previous year's destination was Russia and my brother had gone, lugging an extra suitcase loaded with chewing gum and chocolate bars for trading. He returned with metal badges of Lenin and the Space Race, a carved wooden Kremlin and an Ushanka fur hat. The French trip includes Paris and a stop in Lourdes, and demand for places (because of Paris, not Lourdes) is so high that a raffle is held. I automatically qualify for a place: my crutches are the equivalent of a playoff

clean sheet and my best friend is allowed to be my plus one. She's Protestant, and her religion doesn't hold the same kind of devotion for the Virgin Mary. Neither of us knows if Mary will intercede on my behalf. All eyes are on me, because they think I'm their chance of a miracle.

In 1988, a leap year, I spend all 366 days of the year on crutches.

(Hip)pocratic Hope

The arthritis caused my leg to drag. I got used to the limp, to the noise of the crutches, but with it gained a new self-consciousness. I avoided catching sight of myself in shop windows. Crossing a dance floor or a hall or any room bustling with happy, oblivious people, I slunk along the walls, took the long way round. I entered rooms from the right to disguise my crooked walk. When someone asked what had happened, I always replied that I'd fallen, because this shorthand was easier and quicker and less embarrassing than getting into the story. And that's the nub of it. What I felt more than anything in those years was overwhelming embarrassment. Ashamed of my bones and my scars and the clunking way I walked. I wanted to make myself smaller, to minimise the space I took up. I read that shrews and weasels can shrink their own bones to survive.

On an early visit to the surgeon, to check my spine for scoliosis, I was asked to wear a swimsuit. Mortified, I cried

all through the exam, and the doctor, growing impatient, threw a towel over my lower body.

'*There*, is that better?'

It wasn't, of course. I was a self-conscious girl being humiliated for her shame. Few of us escape teenage self-consciousness, but the complicated roots of female bodily shame are sown early. I knew from pop culture that I should *want* to be looked at, but when regarded, I didn't know how to feel. The doctor–patient relationship had its own imbalances. I have never forgotten the sense of powerlessness in the face of instruction: *lie down, bend forward, walk for me.* I have felt it when counting backwards from ten under the stark lights of an operating theatre. Or when skin is sliced cleanly through. You are in someone else's hands. Steady, competent hands, hopefully – but the patient is never in charge. The kingdom of the sick is not a democracy. And every orthopaedic doctor who examined me during those years was male.

Equilibrium

Lourdes, like Medjugorje or Knock, is an important place of pilgrimage for Catholics. In Ireland today, church parishes still organise trips to France, rounding up busloads of the faithful. In the 1980s, the cheapest option was bus and ferry, before budget airlines began offering €37 flights to Perpignan and Carcassonne. Pilgrims sat next to nouveau riche Irish off to 'Perp' for a weekend of fizz and shopping.

Today, Lourdes has its own airport, squeezing into the title: *Tarbes-Lourdes-Pyrénées*.

When I made the trip in 1988, it was an epic, complicated journey. The ferry ducked and bobbed across a heaving English Channel. Everyone stayed in their cabins vomiting – because of the equilibrium and sheer will required to make it to the bathroom. Our coach rolled off through Rouen and on to the lush gardens of the Palace of Versailles. From there to Paris, with its cafes, the iconic tower. We took endless photos and binged on souvenirs, but I could only think of the grotto, and of what would happen. The drive south to Lourdes took all night and pain made sleeping difficult. We passed vineyards and I watched the stars, listening to the untroubled breaths of deep sleepers. I thought about the baths, and how if I believed it enough, I would be cured.

Os Sacrum

The Bible spins a narrative that women are literally created from bone, that we are fashioned from Adam's rib. We talk of childbearing hips, and of the sturdy pelvis required for birth. Behind muscle and ligament lies the womb: a chalice, a reproductive holy grail that makes life possible. At the base of the spine, between the hips, is the sacrum. From the Latin 'os sacrum', which translates as 'holy bone'. In Ancient Greek animal sacrifices, certain parts of the body were offered up to the gods. The sacrum was included, and was said to be indestructible. Our bodies are sacred, certainly, but they are

often not ours alone. Our hospital body, all rivers of scars; the day-to-day form that we present to the world; the sacrosanct one we show to lovers – we create our own matryoshka bodies, and try to keep one that is just for us. But which one do we keep – the biggest or smallest?

Lapis Lazuli

The hills in Lourdes are vertiginous. They rise, fall and repeat like cartoon geography. Flanked by the Pyrenees, Lourdes is visited by six million tourists a year, and Paris is the only French city with more hotels. The castle, Château fort de Lourdes, can be seen from all around and was once attacked by Charlemagne. Reports of its topography were not wrong – the roads are narrow and the descent to the basilica is steep. Beside it, the Gave de Pau is the fastest flowing river I've ever seen. It loops around the Massabielle rock, where Bernadette saw her first vision of Mary, and here in the rock face is where the grotto stands. Crutches and splints hang from the walls, like oversized Christmas decorations. The concourse teems with people and this surprises me. I hadn't expected it to be so *popular*.

Surrounded by mountains and valleys, Lourdes is remote and self-contained, which sounds strange for a place where faith is amplified. Metaphysical or impalpable, all the elements of religion are made real in these holy spaces. Believers carry their prayers inside themselves, speak them wordlessly in their heads, but here their faith – that elusive,

blind thing – is tangible. There are physical signifiers everywhere, along with commodification. You can take home souvenirs in every form: Virgin Mary-shaped bottles of holy water, Bernadette mise en scène with her friends, cast in alabaster. Garlands of glass rosary beads. Relics in shades of sea and sky, heaped in buckets like mackerel. Blue is considered the colour of holiness, of nature, of truth and heaven, and the shops here are banks of azure and periwinkle. I avoid miraculous medals and crucifixes and buy a View-Master for my younger brother, with rotating rectangular shots of the basilica, Bernadette and the grotto.

'Everywhere We Go (Everywhere We Go)'

The hills were the reason I had to bring a wheelchair. When my mother heard about the up-and-down nature of the streets she borrowed one from the Irish Wheelchair Association. On the day we were due to leave from the school, the coach eased into view and I cried in our car. The arguments had gone on for days: that I didn't need a wheelchair. That once I got into it, everyone's view of me would change.

There would be pity. Deep as a trough.

A crippled girl.

My parents made a strong case – comfort, safety and those hypotenuse hills. Outside the car window, there was excited chatter, with parents pressing extra francs into teenage hands. My father promised he wouldn't load the chair into the baggage hold until everyone, including me, was

on board. He waited, and discreetly heaved it on top of the suitcases. The bus shuddered with its weight. *I just won't use it*, I told myself. Like the swimsuit at the doctor's, the circular routes around dance floors, I felt the familiar burn of shame as we drove to Wexford and the ferry.

Wheelspin

It was a spring day when we arrived, the air not yet warm. When I look at the photos now, I smile at my friends' perms and pastel blouses with shoulder pads; my denim skirt and ankle socks. We don't know what's ahead of us or who we will become. Our shyness is palpable. The hotel bar sold café au lait in small, white cups for three francs, which we asked for in untried French, and sipped, feeling sophisticated. Paddy the bus driver told me I never look him in the eye when I speak as he lifted the wheelchair from the bus. I refused to get into it. Missing the first three months of term in a new school had left me in a hinterland. Fast friendships had already formed, and although I was trying to catch up, I was separate; an island away from my classmates. Now, eight or nine of them, boys and girls, stood silently regarding the chair, while I sank into my own stubbornness. I've thought of this moment many times since, and every time, I remember the panic as a completely physical thing. The internal stomach flip and external cheek flush. The utter hush, the wait for a reaction. The boys grabbed the chair and began to whizz up and down the road outside the hotel.

They pulled wheelies, spun each other around, and it had a domino effect: everyone wanted a go. Our sense of others is frequently wrong. We second guess, and make assumptions. The chair became a comic prop, without making me the butt of the joke. There in the French sunlight, we laughed, and I loved them for their kindness. It mattered more than prayers.

The Weight of Water

When the Virgin Mary appeared to Bernadette in 1858, she revealed that there was a spring beneath Lourdes. The waters are said to have healing powers, and are funnelled into its famous baths. Housed inside a stone structure resembling a cave, they are tended by sturdy women, who have guided thousands of hopeful visitors into the water. We queued, and at my turn, I entered a dark room. A woman instructed me to remove my clothes, and wrapped a wet, white shroud around my body. She asked if I could walk without crutches, and I explained that short distances were manageable. The bath resembled a large stone trough, and, as with the grotto, had a uterine shape: the power of these spaces, whether they're flesh or stone. A step down, and I was eased into the water. The cold – the extremeness, the sting of it – was a jolt. In that barely lit room, these women with their strong arms slowly dipped me backwards. I was immersed with all my prayers and hopes, and for a moment the chill of the water obliterated everything. I wanted it to

seep into my bones and make me new. And after months of thinking about how it would feel, it was already over. My skin was instantly dry. Apart from the purple mottle left by the cold, nothing felt different.

After dark, rain fell hard, sluicing down the hills in streams. Every night, there was a torchlight prayer procession, with thousands of people carrying candles thin as stems. The wax encased in white paper with blue ink images of Mary. With the weather and the terrain, a teacher advised me to swap my crutches for the wheelchair, leaving my hands free to hold a candle. Flames fizzed in the rain and the crowd snaked around the basilica, murmuring prayers and rotating rosary beads in their hands. The mood was sombre but comforting. And in the middle of this crowd of believers, my faith wavered: for the first time since my arrival – mere hours since the holy baths – I didn't think there was a miracle here for me any more.

De Profundis

On our final day, we arrive at the grotto concourse for morning Mass. Hundreds of pilgrims are gathered and the spectrum of illness is striking. There are carers with the gravely ill; adult children with infirm parents. A teacher pushes my wheelchair and we search for a spot to position ourselves. A steward approaches and begins to speak quickly in French, but I don't understand. He grasps the handles of the chair, steering it towards the front of the crowd, where

the immobile and very sick are lined up, not just in wheel-chairs, but also in beds. There are people with oxygen tanks, crumpled bodies – men or women? – who can barely sit up. The steward positions me beside a man in a wheelchair who has a metal frame bolted to his head. He twitches occasion-ally but is otherwise motionless. There is drool on his face, and I want to say something to him but can't. In front of me, another man who could be sixty or ninety lies in a hospital bed. His small frame is tucked tightly in, and the bones in his hand are like filigree. The skin is bruised, with swollen veins, which I recognise as a phlebotomist's attempt to find a vein. Under the blankets, he is a husk, almost not there.

At thirteen, I have never known death but I can sense it here. It clouds the air. I don't want to look at these people, and yet I do look. This is the breakdown of bones, the slowing of a heart, the confinement of our own bodies: beings that once sprung into the world, vibrant and visceral and pulsing with life. But my feeling of terror is trumped by something else, something stronger: I feel like an imposter, with trivial, chalk bones. A woman behind me starts to whimper, softly at first, but then louder until her cries drown out the liturgy. The Mass lasts a long time, and I focus on the rise and fall of responses. People weep, or lie still on their mattresses. In the shadow of the grotto, I know that I will go home, and that I will live with my imperfection; that my surgically altered bones will carry me through the years. And under the cloud-heavy French sky, I am grateful for that.

Via Dolorosa

Two weeks later, I returned to the hospital for a pelvic X-ray. The doctor announced that my bones had deteriorated rapidly and I would need a major operation. Devastated, I tried to focus on gearing up for the complex surgery, rather than the prospect of more missed schooldays. The slow cycle of recovery. The boredom. Today, as an orthopaedic fix, an arthrodesis is only performed on horses – I imagine washed-up purebreds owned by sheikhs, dosed up on anti-inflammatories. It's a last resort for pain relief, and involves fusing the ball-and-socket joint of the hip together using metal plates and screws. To heal fully, the bone solidifies over ten weeks, all of which are spent in a hip spica plaster cast. The cast covered two thirds of my body, from chest bone to toe-tips, and required two people to turn me over. It was a jaundiced white; the layers of mesh together weighed as much as an anchor. During ten weeks of bedpans and confinement, I learned (on the quiet) how to heave its sarcophagus heft out of bed whenever my parents were out. The bones slowly cleaved to each other, rendering movement minimal and the leg shorter. It held fast for twenty years, until two pregnancies sixteen months apart were like a bomb going off in my bones.

Rotation, Abduction

After ten weeks encased in my hip spica (I'm my own ala-
baster statue) a doctor attempts to remove it with a cast saw.
Blade meets skin and I try not to imagine what's happen-
ing beneath the plaster. The pain feels like a scald, of heat
spreading. I explain this to the orthopaedic doctor – this
man I've never met – and he does that thing I'm used to
male doctors doing: *he tells me I'm overreacting*. A rotating
blade is slicing into my flesh, *but I need to calm down*. The
room fills up with screaming. Me, as ventriloquist throwing
pain across the room.

When my mother starts to cry, he demands that she leave
the room.

The blade cuts and cuts, with its own rhythm, and this
man urges it on, like a horse in a race. Fifteen minutes later,
I plead with him to stop and he finally gives up, visibly
annoyed. In an operating theatre the next day, the plaster
is cut away like a sculptor's mould. Under the cast, there
is old skin and new scars now: open, jagged lacerations,
running down each leg like the broken line of a border.
Around them, my limbs look tanned, but this is just weeks
of dead skin layers. The leg swells that night and a nurse
applies a compression bandage. Every time it's removed,
it pulls at the new scabs and the bleeding starts again.
Twenty-something years on, I still have six ghost scars on
my thighs and knees. Vertical lines, pink and fierce, telling
a story.

Hips and Makers

During my second pregnancy, my hip finally deteriorated irreparably but a surgeon tried to explain the pain away as 'just baby blues'. Eventually I convinced a doctor that the only solution to twenty-four-hour pain was a total hip replacement (THR). This was granted as if it was a privilege, rather than something essential. The familiar need to plead and convince, to prove myself worthy of medical intervention. My body is not a question mark, and pain is not a negotiation.

I received a THR in 2010, when my children were tiny. After, I could cross my legs and cycle a bike for the first time in over twenty years. It beeps at airport security checks. I have come to think of all the metal in my body as artificial stars, glistening beneath the skin, a constellation of old and new metal. After years of medical procedures my scars are in double figures, but they too form a familiar landscape. Joints can be replaced, organs transplanted, blood transfused, but the story of our lives is still the story of one body. From ill health to heartbreak, we live inside the same skin, aware of its fragility, grappling with our mortality. Surgery leaves scars; physical markers of a lived experience encountering pain. I think of my children, hoping their lives are free from such moments. That atavism will spare them, and their bodies will fare better than mine.

Sometimes I imagine myself in Lourdes, walking the hills with my ceramic and titanium joint. Looking at all that

stone and religiosity, the grand grotto that frightened me, viewed through the eyes of my lapsed faith and non-belief.

Although I do believe. Not in gods and grottos and relics. But in words and people and music. Our bodies propel us through life, with their own holiness.

Relic and bone.

Chalice and socket.

Grotto and womb.

In moments of distraction, there's a Kristin Hersh song that often floats up from the floor of my mind. I've rolled the words back and forth like oars; sung my children to sleep with it.

> *We have hips and makers*
> *We have a good time*
> *They keep me dancing*
> *Finally it's all right*

And it is all right. When there is a day that is pain free, or the sun shines, or my curious children ask about the lines on my skin. I explain my good luck, grateful that things were not worse. I am an accumulation of all of those sleepless nights and hospital days; of waiting for appointments and wishing I didn't have to keep them; of the raw keel of boredom and self-consciousness illness is. Without those experiences, I would not be a person who picks up those shards and attempts to reshape them on the page. If I had been spared the complicated bones, I would be someone else entirely. Another self, a different map.

Hair

In the 1980s, nearly every six-year-old girl I know has long hair of unremarkable brown, as I do. There is a whole vocabulary for these shades, but mine is frequently referred to as 'mousy', which makes me think of timidity, and of mice in hedgerows. A girl at school passes on a great and mysterious secret: plaiting your hair and leaving it in overnight leads to transformative gorgeousness the next morning. Caught up in this revelation, I bind my locks into tight plaits and pull the blankets over my head. The anticipation, the eye-scrunching excitement, means I barely close my lids on the first night. The bumps are hard to sleep on. *It will be worth it*, I tell myself, already imagining a new me. Waking early, I take my mother's comb, with its collapsible blue and red handles. It's an Afro comb, and I do not know how it came into my mother's possession. Whether it was a gift, or an impulse purchase at a pharmacy counter. It is an excessive tool for the fine, thin hair we both share. I loosen the bobbins and begin to brush, unravelling them as a skein of wool.

And there I am: Rapunzel without the tower, and at six I am ambivalent about princes. A memory appears: Kate Bush

in a video on *Top of the Pops*, all fierceness and red-brown mane, her hair so much part of her essence and energy. In front of the dressing table mirror, with its mottled edges, the plaits loosen. I stare at the waves, at this sea of hair. And for years to come, every time I hear David Bowie's 'Life on Mars', and the line about 'the girl with the mousy hair', I think of those long ago plaits and that old mirror. Of weaving a spell out of your own hair, of how we can alter ourselves with one gesture, in one night.

On a whim, months later, I tell my mother I want to cut off my hair. The hairdresser, my aunt, lives in a terraced house and cuts hair – only women's, never men's – in her kitchen. She is always immaculately made up, lip-glossed and kohl-eyed, with elaborate ash highlights. In less than an hour, mousy chunks are scattered on her lino. I regret it instantly, and for years beg my mother to let me grow it back. She refuses, saying that short hair is 'easier to manage'. My aunt deems it a pageboy style, and every time we return for a trim, my mother tells her to cut it 'like Princess Diana' as she flicks through a magazine. I begin to miss my hair, the feel of it grazing my shoulders. No more night-plaiting and waking to hair that looks like rippled sand after the tide has gone out. On a trip to a family wedding in Liverpool, a man mistakes me for a boy and calls me *son*. I cry for hours. My godmother, who has always had short hair, consoles me. She gives me the first hardback I ever own, bound in red mock leather with gold indented lettering. I read, but don't understand everything in Louisa May Alcott's *Little Women*. These girls are as unique as they are similar. Their close, bonded

friendships make me want to leave suburban eighties Dublin and relocate to their nineteenth-century world. And Jo – surely everyone's favourite *Little Women* character? – does something that makes my admiration of her even greater.

> As she spoke, Jo took off her bonnet, and a general
> outcry arose, for all her abundant hair was cut short.
> *'Your hair! Your beautiful hair! Oh, Jo, how could you?'*

Her newly shorn look invokes horror. Even Jo assumes 'an indifferent air', when it is clear she is distraught at the loss of her hair. *Oh, Jo! We are crop-haired kindred souls!* I think. The books we first read are the ones that indelibly affect us. The characters feel closer to people who are real, who merely happen to live in another time and place. As an only girl, I envied Jo and her sisters. Their closeness and connection was not unlike my friendship with my brothers, but hair was not something I talked to them about.

Jo's reason for cutting off her 'one beauty' is to help the family, who need money. Her sacrifice parallels the narrative in O. Henry's 'The Gift of the Magi', which also places hair at the centre. In the story, Della has some of the most exceptional hair in all of literature:

> [It] fell about her, rippling and shining like a cascade
> of brown waters. It reached below her knee and made
> itself almost a garment for her.

Della's motivation is similar to Jo's. It is Christmas Eve and the opening line tells us how little money she has – 'one dollar and eighty-seven cents'. Desperate to buy her husband

a platinum chain for his beloved watch, she sells her knee-length hair to a wig-maker for twenty dollars. While she waits for Jim to return from work, she thinks: 'Please God, make him think I am still pretty.'

When Jim arrives home, he is shocked by her actions and changed appearance. The tragedy of their situation is elevated when he reveals that he sold his treasured watch to buy expensive (but now useless) tortoiseshell combs for Della's hair. Their mutual sacrifice of precious objects reinforces their love, but not before Della fears her short, unfeminine hair will mean that Jim desires her less. 'Don't you like me just as well, anyhow? I'm me without my hair, ain't I?'

Della's self-definition is through her physical appearance, specifically through the hair that her husband so admires. Her identity is bound up in her looks, and not something that stands alone. The story was published in 1905, when many women stayed home and didn't work. Della is financially dependent on Jim, awaiting his return from work on the day she sells her hair. Economically powerless, she uses the one thing she has as a commodity, and the act of cutting her hair can be seen as either a castration, or an act of empowerment. I didn't have Della's luxurious hair, but cutting mine off at seven felt thrilling initially, until I longed for it to grow back. I had tomboy tendencies, and never felt like I wasn't a girl. Femininity was an abstract, a word I didn't know.

Hair is dead.

Each curl, every dyed or product-plied strand, is resting

in peace. I used to believe the myth that hair continues to grow after we die, but the only part that is alive is inside the follicle under the scalp. And to me, it sounds made up, or just gloriously apt, that head, pubic and armpit hair is known as 'terminal hair'. Keratin, the protein that forms its basis, is the same one found in animal hooves, reptile claws, porcupine quills, and the beaks and feathers of birds. Wing tip to split end, fetlock to forelock, we mammals are a menagerie of polypeptide chains. Each strand contains everything that's ever been in our bloodstream. Are memories there too, lurking between medulla and cuticle, embedded in each lock?

Not dead, but 'terminal'. Protein and protean. Like blood, it's difficult to tell male and female hair apart, but it is women who have been historically judged for their crinicultural choices. Reductively labelled in noir films as blonde, redhead or brunette (a practice that exudes privilege, and ostracizes people of colour and other ethnicities). Hair has been used to define women racially, sexually, religiously. It makes them into temptresses: represents a troika of femininity, fertility, fuckability. This conflict is inherent in Botticelli's *Birth of Venus* where Venus is 'born'. Depicted as new and unsullied as a baby, but represented as a fully formed, voluptuous woman. Naturally she must cloak her nakedness – with what else but a swirling mane. The women of the Pre-Raphaelite paintings have loose, abundant hair, like in *Lady Lilith* by Dante Gabriel Rossetti. According to Jewish tradition, Lilith was Adam's first wife and her name was long associated with female demons (one translation of

her name is 'night hag'). She was created at the same time as Adam, and not, like Eve, from his rib. The relationship soured because Lilith refused to bow to him, considering herself an equal, and not lesser. Emblematic of seduction, in Rossetti's picture she is utterly preoccupied with combing her lush hair. John Everett Millais paints Shakespeare's Ophelia as she drowns in the river, her hair a funereal shroud. If loose, untrammelled hair implies that women are morally questionable, hair pinned up and tied back means the opposite: respectable, prim and obedient. Hair as signifier and symbol represents everything from social position and marital status to sexual availability.

In the song 'Hair', from PJ Harvey's 1992 album *Dry*, the singer gives voice to Delilah, a biblical woman, with one of the most infamous hair stories of all. Delilah is anchored in history as a betrayer and fallen woman because she tells the Philistines the source of Samson's strength. In Harvey's song – as well as her obvious love for Samson – Delilah admires his hair, 'glistening like sun'. She recognises its dual power – that it is possessed of actual strength, but also as a tangible thing she covets. Harvey's lyrics plead: 'My man / My man', as Delilah realises that her betrayal means she can't have him, or his hair. Samson is weakened and defeated without it, but there are other possibilities that come with the loss of hair. As a teenager, I learned that there was power in absence.

Wogan's Barbers was an old, wooden-planked room,

now long gone from Dublin. One Saturday afternoon, aged sixteen, I had made up my mind and took the bus to the city centre. In its dark room (a different kind of waiting room), I queued among old men for an hour. When my turn came, I eased myself into the leather chair and the elderly barber encircled me in a black cape. Upon hearing my request, he shook his head.

'We don't do that for girls.'

Red-faced and watched by other curious customers, I slunk out the door and made my way to another barber-shop. Again I sat down in another leather chair, and the cape ritual began.

'You sure, love?'

'Yep.'

'Last chance, now?'

'Go for it.'

The radio blared, tuned to a 1980s hits station. The clippers slid through my dyed roots, buzzing in my ears. He started in the middle, working outwards, and at first it resembled a samurai's chonmage. In five minutes, it was all gone. Like Maria Falconetti in *The Passion of Joan of Arc* (what must it have been like for an actress in the 1920s to shave her head for a role?). *Shorn.* On the bus home, I wore a hat against the February cold, and the word rolled around my head like a marble. *Shorn.* At school, there was outrage. A talking to. Fears of copycat head-shavings. Enquiries about my health. Jokes about Sinéad O'Connor, who had been on TV that week winning an award. In the months that followed, I was often mistaken for her. One

man insisted I'd been in Filthy McNasty's pub in London, drinking with Shane MacGowan. Every time I've shaved my head, or sported a suedehead of regrowth, there is always a response, especially from men. They are mostly horrified, or bemused; some declared it attractive: but I was always asked to justify myself. To explain what I'd done. And why.

'What did you do to yourself?'

'Did you have a fight with a lawnmower?'

'Are you a lesbian?'

'Why would you make yourself unattractive?'

'But . . . it's like sabotaging yourself.'

'What did your mother say?'

(Note: never 'father'.)

In her book *Girls Will Be Girls: Dressing Up, Playing Parts and Daring to Act Differently*, Emer O'Toole writes about shaving her head as a young woman. O'Toole outlines all the assumptions made about her, from her sexuality and availability to her personality type and demeanour. Having no hair also brought its own stereotypes, many of which were gendered.

> Shaving my head for the first time was not a feminist act, but it kissed my feminist consciousness awake for good. Because I came to see that if people were assuming that I was aggressive because of a shaved head, they had equally been assuming that I was passive because of long hair [. . .] If my short hair made people pigeonhole me as homosexual, my long hair, then, made people pigeonhole me as heterosexual. Long

hair, short hair, conformist, non-conformist, feminine, masculine: I was being gender stereotyped all the time. Suddenly, I had a new way to see.

D-Day, France, 1944. There is joy and celebration in the streets at the news of liberation. A truck pulls up, to the cheers of a gathered crowd. Women, their heads bowed, their faces a mix of sorrow and fear, are slowly hauled down onto the narrow street. Many of these women – young mothers seeking food for their family, a teenage girl, a sex worker – are accused of 'collaboration horizontale', sexual collusion with the enemy, which sometimes led to having a baby with a German soldier. They are paraded in the streets and lined up. A man, prepossessing and determined, holds up a razor. One by one their heads are publicly shaved. The punishment is an attempt at defeminizing them, at chastising them for their traitorous actions, but more for their display of sexuality. These women were known as 'les tondues', from the French 'shorn'. Women who were humiliated and branded sexually, not only in France, but in Germany too, and earlier in Ireland during the War of Independence. A misogynistic act of comeuppance watched by large, heckling crowds.

My first head-shaving was aged sixteen, but there have been many occasions since. Once – classically – after a break-up; then during final year college exams; another to divest

myself of a scalp-burning, high-maintenance bleached crop. The last time was in 2003. From motivation to method, I had little control over this particular haircut. This was the only time I removed the hair myself and the incentive was practical, not aesthetic. There was a diagnosis – a rare and aggressive type of leukaemia. Chemotherapy was just one aspect of the treatment, which began the day after diagnosis, with heavy doses of a drug called Idarubicin. I heard the word as 'Ida Rubisson', and imagined a stern, kindly Jewish matriarch (does she wear a sheitel?). Not all chemotherapy kills hair (Idarubicin, bless her, does) but it doesn't fall out in an instantaneous cartoon moment. There is no KAPOW! and it's gone. You wake up with it on your pillow. You brush it and strands come away in clumps. You watch it slip from your scalp and there is nothing you can do about it. The decision to get rid of it all came down to one thing: my eyes. Constant shedding irritated my lids, and my vision was already affected by the drug regime. Half, but not all, of my eyelashes fell out. My eyebrows thinned and clung on. The friendly Indian nurse – the one paged to deal with difficult, collapsing veins, frequently mine – laughed nervously. 'Are you sure?' she asked, holding the hospital issue clippers. In that moment, I was back in the barbershop, twelve years earlier. *Are you sure?*

It was another cold day, also February, but this time I had no need of a hat. The hospital air was hot, overpowering. The smell of overcooked food and hand scrub. Standing in front of the mirror, Hickman line poking out of my pyjamas, I began to shear. Gita stood open-mouthed and offered

words that alternated between shock and encouragement. I noticed she also did this whenever she tried to coax my ruined veins to surrender some blood. In three minutes, the expensive T-bar highlights were gone. Brushing the hair from my shoulders, I pushed the drip-stand and headed back to my isolation room with its two airlock doors. Most people who get leukaemia require a bone marrow transplant. I didn't need one because my body rallied, responding quickly to the treatment. I discover that after bone marrow, hair is the fastest growing tissue in the body.

In my aunt's kitchen in the 1980s, in a Dublin barber's in the 1990s, in a dedicated leukaemia hospital wing in the 2000s, I have stared at the aftermath of my hair. Strands curled like question marks on the floor.

These are the moments that resurface when reading F. Scott Fitzgerald's 'Bernice Bobs Her Hair'. First published in 1920, it tells the story of a shy, unfashionable Wisconsin girl who goes to stay with her beautiful cousin Marjorie. Marjorie quickly tires of dull Bernice and her lack of social skills. They quarrel (including an admonishment, coincidentally, for quoting *Little Women*) but agree that Marjorie will train Bernice in the art of being desirable and popular. Bernice learns fast, and realises charm and sass bring attention. Her newfound wit sparkles in a series of rehearsed lines, including one coquettish offer to bob her hair.

'I want to be a society vampire, you see,' she announced coolly [. . .]

'Do you believe in bobbed hair?' asked G. Reece [. . .]

'I think it's unmoral,' affirmed Bernice gravely. 'But, of course, you've either got to amuse people or feed 'em or shock 'em.'

Warren, a long-time suitor Marjorie toys with, begins to show an interest in Bernice. Marjorie, realising the flirtatious monster she has created, sets out to sabotage her cousin, calling her bluff so that she is forced to cut off her long, cherished hair in front of a shocked crowd at the barber's.

Bernice saw nothing, heard nothing. Her only living sense told her that this man in the white coat had removed one tortoise-shell comb and then another; that his fingers were fumbling clumsily with unfamiliar hairpins; that this hair, this wonderful hair of hers, was going – she would never again feel its long voluptuous pull as it hung in a dark-brown glory down her back.

Like Della in 'The Gift of the Magi', Bernice can no longer use her tortoiseshell combs. In a 1976 film version with Shelley Duvall in the title role, her hair is not brown, but strawberry blonde, elaborately coiffed, and finished with a pink satin bow. At the crucial scene in the barber's, Bernice knows she can't back down. She takes her seat (again, I'm in Wogan's, sinking into the dark leather chair) and the barber tells her: 'I've never cut a woman's hair before.'

Just as he starts to chop, the camera pans around the

salon to the faces of Marjorie, Warren and her assembled 'friends'. The camera doesn't allow us to watch the horror of the actual haircut, but the faces of the crowd tell us everything.

Bernice is changed in more than appearance. Marjorie's pep talks and flirting lessons have taught her guile and guts. Before she returns to Wisconsin, Bernice gets biblical, Delilah-esque revenge by cutting off Marjorie's plaits in the dark while she sleeps.

Old photos reveal the changing fashions, the good and bad choices when it comes to my hair. An unforgivable 'body wave' for my 1980s Confirmation, the experimental teenage dye spectrum of pink, blue and bleach. Hairstyles, lengths and colours as moments cast in amber. I haven't had really *long* long hair since the days of night-time plaits. As a kid, I fashioned fake 'dos out of braided wool and scarves. I longed for the waist-length locks of others, watching hair flickers with envy. I have owned one genuine, so-expensive-it-looks-real wig. It was dark and sleek, a pristine swirl of synthetic strands. It should be unforgettable, a tangible thing, and yet I only have one memory of it.

During chemotherapy, a patient 'loses' their hair. This has become a jaded euphemism – no one misplaces their hair like keys or glasses. It falls out, and many health insurance companies cover the cost of a wig. Over the phone, a kind woman talked me through my application and explained that a high-end wig is considered 'a prosthesis – like a leg'.

I thought of Frida Kahlo's elaborate red boot, of World War One amputees and their phantom limbs, convinced that a missing extremity of bone and flesh was still there. Post-illness, I never felt that my hair was missing. I didn't imagine that one day it was piled up on my head, hair-sprayed or bee-hived, and the next it was gone. The health insurance customer service rep suggested the name of a specialist hairdresser. During the consultation, he spoke in soothing tones, used to dealing with women who were far more traumatised than me at losing their hair. Most people opt for a replica of the hairstyle they used to have, a sort of post-cancer sheitel. I didn't want that. I wanted the opposite, something that was different from who I was before this had all happened. I chose something long and dark, and the hairdresser lovingly clipped and trimmed the wig as if it were real.

After all of his efforts, I remember wearing it on only one occasion. For weeks, it was wrapped in tissue paper in a box. When I told my best friend that I was writing about this subject – these words on this page, moving me back in time, to books and barbers, art and hospitals – she told me a story about this same wig. She talked of a night out some weeks after I was first discharged from hospital. A group of us met in a dark basement venue on a Friday night. Smoking was still allowed in bars and the air was fogged and close. It was someone's birthday (she thinks) or a friend's band was playing (I think). When she walked in, she saw me across the room, wearing this expensive, not-my-hair wig, which she describes as 'long, dark and vampy'.

'You looked like a frail little bird holding court. Everyone coming up to you to wish you well, and you are more interested in them. I can still vividly feel what it was like to look at you, with that fake hair, and how I welled up. I had to take myself away, so I wouldn't cry in front of you.'

I have no recollection of this night. Or of other nights wearing it; of having long hair, or a simulacrum of it, falling down my back for the first time since childhood. I know that our brains selectively archive trauma, in illness or grief, but why was the wig censored? In my friend's story, I know the venue well, the friends who were there, and yet in my own mind, I am utterly absent from it. Post-illness, in social situations, I talked a lot, filling up most exchanges with questions and monologues, so that I would not have to talk about how I felt or what the doctors were saying. Soon after that night the wig was lost. All seven hundred euro of slick, pseudo-hair disappeared and I don't know how, or where it is. Its loss transforms it into some sort of emblem. A symbol in a folk story, something that came into my life briefly when I needed it, only to vanish instantaneously once its work was done. Or perhaps it sits somewhere, carefully wrapped up, a once-worn thing.

The girl with the mousy hair is long gone. But I have another in my life. Most days, I attempt one of the trickiest tasks known to humankind – brushing the hair of a reluctant small girl before school. To ease this battle of brushes and bobbins, I have had to figure out a strategy. A means of distraction.

It's not ninja stealth, or bribery, or all-out war (I think of the samurai chonmage again).

I use words. And music.

My daughter loves to sing, and constantly asks me to teach her songs. I rummage through my brain, frantically searching for choruses or verses, scraps of tunes. I find ballads and pop songs, songs 'as Gaeilge' (in Irish). Beatles tunes and soundtrack songs from films we've watched together. I brush and wrestle, offsetting each knot by starting a new note. I scoop handfuls of her sweet-smelling hair – identical in colour to mine when I was her age – but refuse to call it 'mousy'.

My hair. Her hair. Me. Her. Us.

Humming a song – we go from bluegrass tunes to Taylor Swift – I fold her soft strands over the comb's teeth. I tell her about the night-plaits and the sea of hair in the morning, the wavy locks like a tide-departed sand.

60,000 Miles of Blood

A+

It was January: dark mornings, frosted hills, ice breath.
 It was January: the year's youth piled up; a snowdrift.
 It was January: six months ago today, we got married.
 It was January: our lives forever altered.

In 1891 Karl Landsteiner published a paper on the influence of diet and nutrition on blood. The Vienna-born scientist's interest was in antibodies, and he is best known for his discovery of the polio virus. His blood research examined the idea that transfusion could be fatal due to the likelihood of agglutination (where red blood cells stick together). In 1900, Landsteiner's research also discovered a connection between red blood cell destruction and the immune system, leading to one of the most important medical discoveries of the twentieth century: blood groups. Initially he identified them as A, B and C (which we now call 'O'), the letters referring to the presence or absence of antigens (a substance foreign to the body that can stimulate

35

the production of antibodies). Two years after Landsteiner's initial findings, two Vienna colleagues identified the rarer AB type, and in 1907, Czech scientist Jan Janský isolated all of the blood groups, labelling them with Roman numerals. Without these systems, intra-transfusion death would be higher, and the uncontested idea that all human blood is the same would also have persisted.

Most people move through life never knowing what their blood group is. Unless they require surgery, or have a baby, an individual might never find out. My blood group is A+, a fact I had forgotten until doctors told me there was something wrong with it. Years earlier, in childhood hospital corridors, I would hear a man's footsteps and fill with dread. The phlebotomist – the medic that takes blood from patients – would approach, in search of my arm and a well-behaved vein. The one who took my blood as a teen-ager was unfeasibly tall and wild-haired; my mother said he looked like Frankenstein's monster. He was, like many doctors I met back then, almost mute, but he at least offered up the A+ information when I asked.

It is not difficult to be curious about this substance: its ne-cessity, the silent unassuming way it moves around the body. Some years after I had recovered, I was invited to speak to a room of a thousand blood donors, who were gathered at a dinner to be commended for donating thousands of units. In awe of their collective kindness, I told my story, of how without them, I would not be alive today. Medals were awarded to people who had hit milestone donations. What

motivates a person to give up their time – their blood – for someone they'll never meet?

Of all our bodily fluids, blood – to me – is the most fascinating and the most complex. It has distinct connotations in art, sex, spirituality and ancestry. History is full of blood stories, of sacrifice and war, medicine and myth. Herodotus wrote, in the fifth century BC, that the Scythians drank the blood of their slain enemies, using their skulls as tankards. In Ancient Rome, it was believed that drinking the blood of a dead gladiator could cure epilepsy. Blood has seeped – fluid and uncompromising – into our language and etymology: in cold-blooded killers or hot-blooded lovers; blood magic and blood diamonds; blood moon, blood rain and blood lust. Blood – as we're repeatedly told – is thicker than water. Working a circuitous route around veins and arteries, with its own directional rules. Each day, the heart pumps 7,500 litres of it around our bodies. It makes up 7 per cent of our body weight and is in every part of us, from fingertip to scalp and each skin crease. Breast cancer, a broken limb, cirrhosis are localised, but a blood disorder is a whole body issue. Unanchored, migrant – blood is its own diaspora. There is no part of the body it can't reach. A nurse who specialised in collapsed veins used to come to take my 'peripheral bloods', i.e. blood extracted from an arm, not an intravenous medical line. Peripheral made me think of the edges of my body, of my skin as a boundary wall.

Blood is most physically evident when summoned to specific sites: to a cut, a blush or an erection. Marshalled by

the heart to locales of trauma, panic and arousal. When it accompanies sexual stimulation in both sexes, tumescence – a gloriously lofty and underused word – is assumed to just refer to male genitalia. More than liquid red, more than oxygenated fuel, blood is a complex compound of platelets and leukocytes, plasma and neutrophils. Blood runs as rivers and tributaries within us; deltas crisscrossing over organs, under ligament and around bone. But blood does not rise in the mountains and journey outwards to the sea. It circles unceasingly within us, even in sleep, or paralysis and comatose states.

Blood donation is that rare and uncomplicated incidence of a selfless good deed. The taking of time to attend a clinic, the ritualistic act of allowing a nurse to drain blood. The Irish Blood Transfusion Service collectively describes blood, platelets and plasma as 'blood products': strangely consumerist language for an act that is devoid of the politics of transaction. There is no monetary benefit to the donor, no thank you card. Anonymity is an essential aspect of the donor–recipient relationship, and despite this, I have remained curious about all the blood I've received. Post-surgery, post-childbirth and in chemotherapy I've received around 150 units. A unit is one bag; it contains 470 millilitres, so almost 70,500 millilitres of other people's blood have been inserted into my body. An altruistic army, none of whom will ever know who received their blood; that a part of them is now part of me.

Long before transfusion existed, doctors prescribed a

different kind of intravenous treatment. Not the addition of blood, but bloodletting. George Washington had five pints removed in the hours before his death in 1799, while Mozart agreed to the process to treat his rheumatic fever. As well as cutting hair, barbers used to perform bloodletting, and the red and white of a traditional barber's pole represents blood and bandages. I had no idea how much blood can be lost in surgery, until I underwent multiple operations myself. Lying on an operating table for a C-section, the sheer volume of spilled blood was a shock. Later, my husband said it looked like a murder scene.

So easily spilled and yet still a commodity: blood has a market value. In the years from 1998 to 2003, it trebled in Ireland. In the US, start-up company Ambrosia harvests the blood of under-25s, with wealthy donees over the age of sixty paying more than $8,000 for a transfusion of youthful blood. Transhumanists are interested in what has been called parabiosis (which initially began decades ago, with the stitching together of rats' vascular systems). Billionaire entrepreneur Peter Thiel has reportedly been injected with the blood of others, and has contributed financially to research on the process. Naturally, it's an option open to only the very rich, fixated on eternal life.

Prick a spot anywhere on the surface of the body, and your blood is instantly summoned. I conjure up a supercut of every gash I've ever had – bloodied legs after a bike crash, nicks from teenage leg-shaving, a small, red crevice after a rock was thrown at my head. I didn't bleed when a

car knocked me down, and I've never had an accidental cut so big I needed to be sewn back up. Platelets knit the skin back together, pooling at the site of an opening, literally plugging the wound. Blood helps the body to fix itself, and yet still, like everything else, it has a price.

A-

If you take all the blood vessels in an adult body – veins, arteries and capillaries – and lay them out in a continuous line, they're said to measure 60,000 miles. Typing these words, fingers depressing keys, there is the movement of tendons across a pale landscape of skin, but what I notice most is the blue of the veins. Every slim stream, each a messenger of the blood, working away unacknowledged. Over the years, several cannulas have been attached to my arms, pre-surgery, or when the veins at the elbow collapsed like a coal tunnel. Each time, a phlebotomist offers words as preparation, but they are never the right words, always inaccurate about the sensation that follows. 'You'll feel a scratch, or a nick,' they say. It feels like neither.

In my late twenties, six months to the day since I married my husband, I found myself in an ambulance on a cold, glass-clear January morning, a paramedic holding me upright because it was too painful to sit, or lie on a stretcher. Later, in the hum and chaos of the hospital, I was told that something of concern lurked in my blood. I hadn't suspected there was anything wrong until I found I could not bear any weight on my right leg. I guessed at a pulled muscle; and tried elevation and tight bandages. The throb and sear of it continued, and a doctor dispatched me to casualty, where I waited on a trolley in a tiny room beside two pensioners. That I was stationary for seventy-two hours

now seems terrifying given that the eventual diagnosis was deep vein thrombosis (DVT). The blood in my calf vein had slowed and coagulated into a blocked knot.

A doctor speculated that it was caused by the contraceptive pill, so anticoagulants were administered in elephantine doses. Weekly visits to a Warfarin clinic followed, an airless room where I sat among old women, a sea of silver, heat-treated hair, the youngest person by decades. Warfarin, a mass-market blood-thinner, comes in a trio of strengths and colours: pink the strongest, followed by blue, then brown. A handful of pinks is an indicator of having treacle-thick blood. No matter what colours I took, in rainbow combinations, my coagulation level bounced around like a skimmed stone on water. A persistent cough percolated in my lungs, and one day I woke to find my legs dotted with black bruises. Not just a handful, but more than twenty mottled circles. They weren't trauma-inflicted so they didn't hurt – and I now know that this phenomenon has a name, *ecchymosis*, from New Latin, and Greek *ekkhumōsis*, 'to pour out'. The cause of the bruises was blood leaking from a blood vessel under the skin. The colour frightened me. It wasn't recognizable as anything from the usual bruise spectrum – night sky, purple, pond-green. Everything felt ominous. Night sweats woke me constantly and it felt like there was worse to come. What was happening to me?

With illness, there is always a sense of a 'before' and an 'after'. The before time when everything is bright and even-keel and normal, a word that loses all meaning in the face of disease. The final moments of 'before', just as it slowly

dawned that bad news was coming, was when a haematology registrar – kind, blonde, about my age – used the word 'blast'. Her reference was not to having fun, or *Star Wars* gunshots, or a wind gust that cuts you in half, but to myeloblasts, immature white blood cells that spill out from the bone marrow. This was a new word, and, used in a medical context, was enough to ping the synapses, to make me ready myself. I didn't yet know that a 'blast level' – having 20 per cent or more myeloblasts in the marrow – is a strong indicator of blood cancer. I fished for answers, dropping a line into this new, terrifying water. The haematologist was circumspect, eventually admitting there was an irregularity in the bone marrow. 'Like leukaemia?' I asked. In that moment, I did not know where that question came from, or how I made such a leap from bone marrow to cancer, but what did I know in this land of 'before'? To be an undiagnosed patient is to be in a constant state of fear, of waiting for the revelation. Offering a hazarded guess is an attempt to compute, or accelerate the truth. On that Sunday, it felt like weighing up the facts of my body.

The black bruises and night sweats and chest-heaving cough were coming from *somewhere*. It took me weeks to realise where that panicked guess had come from. In the late 1980s when I was a teenager, my mother's friend was diagnosed with leukaemia. I had heard the words 'bone marrow' used about her cancer. At the time she was ill, she was treated in the same Dublin hospital that I was now in. The haematology ward was in an old building, one that I still attended in the early days of my diagnosis, and all kinds of blood

disorders were treated there. In another room on her floor was Irish TV presenter Vincent Hanley. I had religiously watched his music show, *MT-USA*. He had introduced me to Kraftwerk, by playing the video for 'Musique Non-Stop'. I duly taped it, showing its robot graphics solemnly to a friend to gauge her reaction, and became an instant, committed fan at twelve.

Hanley had been moved from a private hospital to St James's, and was under the care of a team who were keen to protect his privacy. The first cases of HIV in Ireland had been identified in the early 1980s. Many were haemophiliacs who had received contaminated factor VIII and factor IX, pooled blood products to aid normal coagulation. Sex workers, intravenous drug users and gay men were also being diagnosed, and with it came stigmatization. In 1987, the press was already speculating that as a gay man, Hanley was dying of AIDS.

In the first months of my illness, I spent many outpatient hours on the ground floor of that old building. I thought of my mother's friend often, who had succumbed to her leukaemia in 1992, and of Hanley, who had just turned thirty-three when he died in 1987 of an AIDS-related illness. The corridor was dreary and under-lit, the accrual of old gloss on the doorframes a 1950s throwback. I now associate the dull rooms off that main corridor with the small increments of bad news: infections and a large haematoma. The high-ceilinged waiting room with its porthole windows that made

everyone wish they were sailing away, or already far out on the ocean. That they were anywhere but here.

The clot in my calf expanded and broke off, scaling my thigh like a rogue climber, making its way up to my lung. Doctors took turns to listen with stethoscopes while a professor explained to his accompanying interns – as if talking about changing a tyre – that a lung clot has a very specific sound, its own sonic signifier. I coughed up part of it that first week. Against the pristine enamel of the hospital sink, it looked like a crushed raspberry.

The diagnosis was Acute Promyelocytic Leukaemia (APML), a rare strain of AML that is aggressive and advances quickly. 2017 was the sixtieth anniversary of its classification by Norwegian haematologist Leif Hillestad. When it was discovered, the average survival time on diagnosis was less than a week. Today, most people survive longer, but the usual cause of death is a bleed in the brain or pulmonary haemorrhage (similar to the one lodged in my lung). These death stats came from the internet, even though I knew at the time that googling an illness was a bad idea. Online diagnosis is compulsive, but without nuance. On the first night in hospital, I had several transfusions of blood and platelets. Hooked up to a drug pump, I watched bags of gloopy fluids funnelling into my veins. How ironic that blood cancers start in the marrow of the bones, given my troubled orthopaedic history. The two diagnoses were distinct and decades apart but now shared an odd, osseous connection. From my bed, I called my brother in Australia and listened to him cry down

the phone. In the morning, full of drugs and blood, I vomited up litres of black. *Is that the cancer?* I wondered.

Chemotherapy started the next day, and a triple-prong Hickman line was inserted into my chest to administer it, as well as other drugs and anticoagulants. Its plastic tube was inserted under the skin of the chest wall and into the superior vena cava, a large vein leading to the right atrium of the heart. It sat there, a casket buried in my chest, with cell tissue growing around it. When it came time to remove it six months later, it refused to budge. It had become a part of my body, and part of me clung to it. A nurse attempted to part us with a scalpel and no anaesthetic, and blood geysered everywhere. Her efforts have left four permanent scars on my neck.

B+

A man, knees tucked under him, kneels on a white stage, his body an upright L-shape. From heel to shaved head, he is painted in thick, white paint. A droning, anti-orchestral soundtrack plays. Artist Franko B, born in Milan in 1960, also paints and draws, but is best known for his performance pieces involving him bleeding from needles in his arms. In *I'm Not Your Babe* (1995–6), the viewer must consider if he's performing pain, or *in* pain, genuinely depleted by the blood loss. It's a disorienting work, one that could be both funeral and resurrection. Of all of his blood pieces, it is *Oh Lover Boy* (2001–5) that I watch over and over. An audience sits behind hospital privacy screens, which are removed to reveal the artist lying on what could be a blank canvas, bleeding at an angle. Franko B is both artist and object, served to the viewer, minimally plated up for our consumption. When I watch it, I see an operating table or mortuary slab. This piece is the most surgical of his work. Painted garish white from head to toe, save for the blood exiting his arms, the pose is of a medicalised Christ, a static stigmatic.

Unlike his previous performance pieces, there is little motion in *Oh Lover Boy*, except for when Franko B clenches his fists to speed up the blood flow. The white paint exaggerates his Caucasian masculinity, but his nakedness emphasises how vulnerable he is. His blood streams into a gulley, where it's collected, and at the end, he sits up and looks puzzled,

almost childlike. He removes himself from the table, leaving behind rivulets of blood and the imprint of his body. A near perfect facsimile of the self that had lain there. I find it mesmerizing and moving, this work that explores our mortality, the sheer ephemerality of a body, of a life.

It was filmed for posterity (or perhaps permanence, unlike the blood he loses?) and there is an overhead shot, a full contemplation of the scene that's like an out-of-body experience, a pietà, without the Virgin Mary. As I watch it, I see life and death, stillness and vitality, art and biology. Franko transforms the corporeal into something philosophical. Watching his performances is a complicated encounter: this isn't a canvas or sculpture, it's alive. Franko is not merely the artist representing something thematic; he *is* the work, and the work is him. His bleeding makes sense to me and feels vital, in a way that a static painting could never achieve.

Watching this blood-spill-as-art, or the methodical drip of my own transfusions, made me notice more about the liquid itself: the depth of colour, its thickness, its weight. Blood in bags is darker, and slightly sinister to behold. In its sealed vacuum, it has an intensity that blood from a cut doesn't possess. Those who have never been proximate to blood only have screen props as reference points, as cinema attempts to capture it. The liquid circling the drain in *Psycho*'s shower scene is chocolate sauce. The most vivid scene in *Carrie* centres not just on blood, but its provenance and texture. Sissy Spacek in sash and crown as prom queen is reeled in from the margins of Outsiderland, until a waterfall of pigs' blood, syrupy and paint-thick, is tipped over

her from above. Haemoglobin-soaked, Carrie takes her telekinetic, red-misted revenge. The scene is a masterpiece in pacing and tension. Of the entire film, it's the colour and texture of the pigs' blood, sloshing around in a bucket, that I remember most.

B-

There is no equality without reproductive rights, there
are no reproductive rights without respect for the
female body, there is no respect for the female body
without knowledge of blood.
Christen Clifford, from *I Want Your Blood*

From a bloodstain on a wall, it's impossible to distinguish
if a person is male or female. Unless you look for certain
markers in a laboratory, or the presence or absence of a
Y-chromosome. Men have higher platelet counts and
haemoglobin levels, but this isn't a definitive means of iden-
tification. The shedding of blood has historically been seen
as a male act of heroism: from rite-of-passage fistfights,
to contact sports and combat. Infrequent, random events
seen as standalone milestones; stories to tell once the pain –
and enough time – has passed. Female bleeding is more
mundane, more frequent, more get-on-with-it, despite its
existence being the reason that every single life begins.

Periods are by now well documented as inconvenient and
painful, and for most women, a cyclical ritual to be endured
for half a lifetime. The red slash and knicker-flash of it;
the declaratory scarlet of day one, to darker, viscous frag-
ments. During a period, the lining of the womb detaches
itself and is shed, along with the unfertilized egg. Period
blood is actually only 50 per cent blood: the rest is made

up of cervical mucus and endometrial tissue. This monthly evacuation makes this substance an oxymoron: even though it symbolises the possibility of new life, it is more akin to waste. Bleeding as fecundity, as a signifier of fertility: blood as not-pregnant relief, or not-pregnant disappointment. In *The Female Eunuch*, Germaine Greer suggested – long before her anti-trans rhetoric and problematic views on rape – that for women to get to know their bodies, they should sample this secretion for themselves: 'If you think you are emancipated, you might consider the idea of tasting your own menstrual blood – if it makes you sick, you've got a long way to go, baby', she wrote. It has a tang of iron, and in the early days of my first pregnancy all I could taste was metal. My mouth full of rust.

Despite the biological truth of its redness, it's not long since the days of blue liquid being used on television adverts to demonstrate sanitary towel absorption. It took until 2017, in Bodyform's 'Blood Normal' campaign, to show red liquid in an ad. The horror of showing actual blood was too much. A generation of young women laughed at the adverts showing TV versions of ourselves on roller skates or frolicking in white trousers. There was never a leaked streak of red in sight – not a chance – unlike *Period*, the photo series by sisters Rupi and Prabh Kaur, first posted on Instagram in 2015. The images chart Rupi Kaur's experience with her own menstrual blood: lying down with blood visible on her clothing; with blood-stained legs in the shower; a stained bed sheet spilling out of a washing machine. Kaur's work makes visible what women are meant to conceal. It

obliterates the taboo of menstruation as something to be dealt with secretly, to be endured indoors and kept hidden. These images render the private public.

Two decades earlier, when Tracey Emin's iconic installation *My Bed* was first exhibited in 1999 at the Tate Gallery, reactions were swift and varied. There was particular horror at Emin's inclusion of her underwear, stained with period blood. Art encourages the shedding of boundaries, but Emin was said to have transgressed. She had revealed something she shouldn't have: something that came from her body, her female self. This is despite the fact that the artistic body has always been public. If Emin had lain on the bed herself, fully naked, as her own installation, it would have caused less consternation than the fact of her bloodied underwear.

In 2015, then Republican presidential candidate Donald Trump took part in a debate on Fox News, moderated by journalist Megyn Kelly. Trump, not keen on the line of questioning, remarked afterwards: 'You could see there was blood coming out of her eyes. Blood coming out of her wherever.' Sarah Levy, a Portland artist, heard Trump's remarks and painted a portrait of him – in her own menstrual blood. Trump's sexist critique of a woman was turned back on him. There have been many women artists to do this before Levy: Judy Chicago's solo work in the 1970s and her group installation with other female artists on *Womanhouse*; Christen Clifford's *I Want Your Blood* (2013), 'a Feminist Public Action in three parts'; Jen Lewis's period-blood fish tank photographs; New York artist Sandy Kim's

images taken post-period-sex; Ingrid Berthon-Moine's *Red is the Colour* (2009), with its portraits that resemble fashion headshots of women complete with statement red lips of menstrual blood. In 2000, artist Vanessa Tiegs, who paints using period blood, coined a collective term for this medium: 'Menstrala'. Naming it not only created a movement, but legitimised a community united in its experimentation and its championing of something natural that had made women other. Women have been shamed for bleeding, encouraged to hide the process and their response to it. Using it as a medium in art is a feminist act of reclamation and confrontation.

Blood as a tool of confrontation was central to the art of Ana Mendieta. Born in Cuba in 1948, Mendieta dedicated her life's work to using her body as a political tool. In performance art, film and photographs, she repeatedly returned to the idea of blood as a symbol of both patriarchal male violence against women, and the power of female sexuality. In the 1973 short film *Sweating Blood*, Mendieta – eyes closed – is immovable, as blood appears to trickle from her hair. One of her most confrontational pieces was in response to the 1973 rape and murder of a fellow student at the University of Iowa. Mendieta recreated the crime scene in detail, and invited students and professors to come to her apartment at a specific time. There, they happened upon the scene of Mendieta bloodied, naked on a table and 'dead'. Mendieta used blood to remind her audience of the impermanence of life and the materiality of a body. For

her, blood was sex and magic; and a visceral memento mori steeped in female experience.

The treatment for the clots that appeared in my leg and chest involved them being broken down with drugs and absorbed back into my body. Periods have masses of their own – congealed clots, the clumped lining, lumps the colour of liver in a butcher's shop window – that are in the end expelled from the body. For a few months of my life, Congealment A (DVT) and Congealment B (menstruation) overlapped. The leg clot and pulmonary embolism ran untethered through my veins, a venous Bonnie and Clyde. With this kind of runaway coagulation, bleeding of any kind is dangerous. My blood count dropped with each round of treatment, making me vulnerable to infection. Losing more blood was unwise. The consultant prescribed a drug to halt menstruation, and also explained that the high doses of chemotherapy I was being prescribed could affect my fertility. I thought about not bleeding, and equated it with my body not working, of it failing. A break from menstruation felt like a moratorium on one aspect of being female. There are gaps in my memory from this time. Things my brain hasn't allowed me to hold on to. The name of the drug in question is long forgotten so I type a vague search term into Google: 'drugs to stop periods' and 'cancer' – it appears instantly. It happens every time I do these searches for multi-syllable drugs or obscure treatment names that elude me. When they flash up on screen, there is instant, uneasy recognition.

Allowed home from hospital, I had to give myself daily anticoagulation injections that went like this: wipe skin with alcohol swab, open disposable needle, insert into vial, withdraw syringe, flick to disperse air bubbles, pinch thumbful of stomach skin, insert needle and push. With subcutaneous jabs, I rarely saw blood, except for the occasional tiny orb at the point of entry. I owned a sharps bin in garish yellow and blue, with a *Warning!* sign on the front. Like the sanitary bins in toilet cubicles, these boxes are about safety, but also about concealment. A reminder that my blood, peripheral or menstrual, is a biohazard.

O+

In the 'after' part of illness, my vocabulary expanded. There were new words every day: embolism, infarction, neutrophils, anthracyclines. Words to describe things I couldn't see. There were needles – hundreds of them. Blood culture tests that looked like Tabasco sauce bottles full of vinaigrette. The Hickman exited my chest, reminding me of the Borg in *Star Trek*. When I could not eat, I was fed a complex liquid through it. The container resembled an old milk bottle. The Hickman caused a haematoma the size of a golf ball, a soft mass of old, curdled blood. I rolled my fingers over it; my skin felt velvet.

I've had blood transfusions for various surgeries, including the hip replacement. Having a previous lung clot meant taking a pass on full anaesthetic. During the five-hour surgery I was sedated, but mid-operation, I woke up. Not fully, but enough to know I was awake, and to wonder what was wrong with the spinal block, or if this was some sort of chemical trip, to feel a shove in the area where a surgeon was trying to insert my new joint. 'Who's pushing me?' I slurred. The dosage was hastily topped up and I slipped back under the waves. I lost a lot of blood. In the recovery room afterwards, a blue-scrubbed nurse explained that my colour was a concern and set up a transfusion. I drifted back into the etherised calm and woke to a bag of blood swinging on an IV stand above my head. Bright and fierce, its own plastic heart.

Blood's redness is caused by the iron-containing protein haemoglobin, which carries oxygen to the lungs. Whenever I saw the word written down, it appeared mixed up. HaemoGOBLIN: an evil sprite lurking in my blood vessels, casting spells. When I think of these red cells, crowding through veins, of blood throbbing in my ears, a vein jumps in my arm, and I think not of the sound, or the rise and fall of skin, but only of the sheer redness beneath.

O-

On the haematology ward, the blood tubes have colour-coded bands and are stacked in neat rows.

Purple (full blood count)
Light blue (coagulation)
Ochre (virology)
Green (plasma)
Pink (blood group and cross-match, in case of
 transfusion)

Needle in arm – *You'll just feel a scratch* – I look away from my skin to the rainbow line of branded tubes: VACUETTE. Every time a nurse fills one with my blood, I want to ask, 'Wouldn't The Vacuettes be a great name for an all-girl punk band?' But I never do. I try not to focus on the extraction. Vacuette could also be the name of a French heroine in a romance novel or slang for dim mean-girls. My vein resists and the needle goes astray. Avoiding the puncture, and the blood on my arm, I focus instead on the blue and yellow sharps bin, and recall team colours:

Football: *Wimbledon, Mansfield Town, Oxford United.*
GAA: *Roscommon, Wicklow, Longford, Clare, Tipperary.*

Vacuette. I turn the word over, assuming it comes from 'vacuum', as in void; an empty place waiting to be filled. Its purpose only complete on the receipt of blood.

American artist Barton Beneš (1942–2012) was interested

in the idea of receptacles-as-art. In exploring the possibilities of such a minute space, he used his work to make a social and political point; to give agency to his personal situation through his art. During his life, Beneš's main medium was sculpture, but when he was diagnosed as HIV positive, he changed tack. He reached for things around him that represented what was happening in his blood. *Palette* (1998) is a traditional artist's palette covered in capsules and pills, made not from paint, but from Beneš's own HIV drugs. In two versions of *Talisman* (1994), antiretroviral drug capsules are intertwined with beads and US dollars to resemble rosary beads. Beneš's tools are deliberate: a means to link religion and faith to illness, yes, but also commentary on the exorbitant cost of HIV drugs in the 1980s. If medication is used as commodity why not use it as art?

To me, Beneš's most arresting work began when he started to use his own blood, initially in pieces like *Transubstantiations, 3*, where a syringe of his HIV+ blood is shown with coloured feathers attached. It appears less as medical hardware and more as an arrow, with the fletched feathers suggestive of a Native American weapon. The religious is both routine and ritualistic in Beneš's art, not just as a source of hope, or healing, but connected to Jesus's bleeding on the cross – the open wound in his side analogous to the ongoing AIDS crisis. In *Crown of Thorns* (1996) Beneš took this further by weaving needles and IV tubes full of his infected blood into a crucifixion crown, to produce a delicate and devastating piece of work.

In the 1980s, AIDS decimated the gay community in

his adopted city of New York. In its early days, many didn't know they'd been infected. Beneš lost swathes of friends – including his lover – to the disease, and his art was an attempt to come to terms with all the loss. 'I never knew what to do about AIDS. It was a hard subject for me,' he once told CNN. Proximity to the horror of what was happening to his community, the incomprehension, the reckoning with his own illness, led to the most compelling of pieces, the blood-art series *Lethal Weapons* (1992–7). It presents thirty receptacles containing his and other people's HIV+ blood, including *Silencer*, 1993 (water pistol), *Essence*, 1994 (perfume atomiser), *Holy Water*, 1992 (holy water bottle), *Absolute Beneš*, 1994 (miniature bottle of Absolut vodka), *Venomous Rose*, 1993 (joke flower) and *Molotov Cocktail*, 1994. Humorous and poignant, the show's European tour was controversial. Sweden's health minister shut it down, while tabloids dubbed Beneš an 'Art Terrorist'. One newspaper called it an 'AIDS Horror Show', but Beneš took objects of romance, comedy and religion, and repurposed them as art. How else should you confront your own mortality through art? Or respond to the premature ending of a life?

On the night of my leukaemia diagnosis, I could not face telling my parents the news. Fearing their reaction, I asked the nurse to. I readied myself in my bed, waiting for them to appear around the curtain. I will never forget their faces, their incomprehension and tears. Amid all the wrongness of that moment, I knew something was required of me. To hide my fear and offer them a glimpse of a future none

of us knew had any certainty. I have no memory of this but my mother told me years later that I looked into her face and said, 'I'm not going to die. I'm going to write a book.' To commit to writing, or art, is to commit to living. A self-imposed deadline as a means of continued existence. It has taken me a long time to write that book and here I am, so very far from that awful night.

Art is about interpreting our own experience. Upon entering hospitals, or haematology wards, our identity changes. We move from artist or parent or sibling to patient, one of the sick. We hand over the liquid in our veins to have it microscoped and pipetted. Beneš used his art as tenancy. If hospital tubes could house his blood, so could his own work. Beneš knew that if his blood had to be anywhere other than in his veins, he might as well use it as an aesthetic agenda; a declaration of possession.

AB+

Growing up in a Catholic country, it's understood early on that blood is highly symbolic. No member of the faithful is ever allowed to forget that Jesus bleeds: from the crown of thorns on his head to the wounds in his hands and feet. It is said that as he hung on the cross, a Roman soldier pierced his side and blood *and* water flowed out of him. Life-giving fluids, both elemental constituents of the body. The act of bleeding makes him mortal, vulnerable, and more like 'one of us'. Whenever the word 'blood' is used in the Bible, it refers to Jesus's self-sacrifice. 'Blood of Christ', for Christians, is literally Jesus giving himself up to save their tainted souls.

> *Take this, all of you, and drink from it,*
> *for this is the cup of my Blood,*
> *the Blood of the new and ever-lasting covenant,*
> *that will be shed for you and for all,*
> *so that sins may be forgiven.*
> *Do this in memory of me.*

I am a much-lapsed Catholic and have not attended Mass in decades, but when I go to funerals or weddings, every word of this incantation still rises up from memory. I could recite it if I had to. Even the most established and conservative of religions are deeply embedded in ritual. The Eucharistic rite of Mass is almost tribal, and I imagine drums and burning bonfires when I hear it. It mimics

voodoo, blood magic and sorcery. Kneeling on hundreds of pews over the years, I've been deeply suspicious. The line about 'the cup of my blood' makes me think of Macbeth's witches. *Double, double toil and trouble*. Transubstantiation is mere sleight of hand: a wine-to-blood illusion that is based purely on faith. A congregation must believe that a communion wafer metamorphoses into flesh, and a gold goblet of wine becomes the red cells of Jesus. This is a big ask, requiring a collective suspension of disbelief, and the same blind faith that makes people believe in immortality, or an interventionist God.

A friend's father told me recently about how, as a child, his sister almost severed his fingers with a hatchet when they were chopping sticks. A local woman had a 'blood prayer' and his mother carried him in her arms to the woman's house, leaving a scarlet trail down the street. The prayer is said to stop bleeding in humans and animals, and can only be imparted from a person of the opposite sex. It goes:

Our Lord Jesus Christ that was born in the
stable in Bethlehem, baptised by St John in
the River Jordan, stop this blood of <PERSON>
in the name of Jesus Christ.

My friend's father said the blood gush ceased immediately, and his fingers – and life – were saved.

AB-

A box arrives in the post, containing a plastic test tube, which I have to fill to a dotted line with the right amount of saliva. *Who do you think you are?* Doctors have said enough over the years to make me curious about my DNA and what's in that double helix. I register the tube online, and go to return the box to the US company. Outside the post office, traffic bustles around me, and people pass who will never know the detail in their chromosomes. I pause for a moment, not so much a hesitation as a reflection, and drop the package into the green mouth of the post box.

Doctors decided on a two-prong approach to treat my APML, employing a combination of standard chemotherapy – in oversized syringes of red and green that look like Gulliver props – and a relatively new drug called ATRA, which only works on this strain of leukaemia. The treatment is called the Spanish Protocol, because Latin American and Iberian people have been shown to have a higher incidence of the disease. I am fascinated by where this Hispanic streak might have come from. In Irish myth, the first colonisers of our island were the Milesians. In the medieval *Lebor Gabála Érenn* ('The Book of the Taking of Ireland'), they were said to be Gaels who travelled here from Iberia, onwards from southern Russia. Others cite sailors who settled here after Spanish Armada ships sank off the Irish coast in the sixteenth century. There is no

definitive proof of either this theory or my ancestry, but author and filmmaker Bob Quinn in *Atlantean* writes of an ancient sea-trade route from North Africa up through the Atlantic off the west coast of Ireland. He notes common characteristics (including a Berber influence) as a possible Hiberno-Iberian population. For days, I refresh the DNA website waiting for my results.

My daughter was born a whole month premature, tiny and incubated, a curled ball of flesh. A paediatrician came to examine her and, glancing at her spine, or her skin, or some other unknowable part of her, declared: 'I see she's not a true Celt.' Post-surgery, I was drained, groggy and full of opiates. Not alert enough to ask what this meant. If she wasn't a Celt, what was she? Along with the Iberian susceptibility to APML and my general ancestral curiosity, this throwaway judgement fed into my sending off the bubble-wrapped tube of spit.

When the results arrive weeks later, they reveal that I am not 100 per cent Irish. The breakdown of my DNA is 91.5 per cent British and Irish, 4.2 per cent is North-Western European, a further 2.4 per cent is specifically Scandinavian, 0.3 per cent Eastern European, 0.1 per cent East Asian and Native American, and 0.1 per cent Yakut, a people of Eastern Russian. So far, so glaringly absent in terms of a Spanish or Latin population group (0 per cent for both). The results appear on a map, and I notice that all of South America is highlighted, so perhaps this is the Latin link. My haplogroup (a genetic population group of people with a common ancestor), T2e, is a sub-haplogroup

of T2, more prevalent in Mediterranean Europe. I dig further, and discover that T2e has a possible link to the Sephardic Jews, who lived in Spain and Portugal around AD 1000. In the fifteenth century they were expelled and fled to Bulgaria. 'Sephardi' translates as 'Spanish' or 'Hispanic', from the Hebrew 'Sepharad'. Until me, there was a deeply embedded Catholicism in my family, and I'm amused by the idea of a possible ancestral connection to Wandering Jews. Of course, I am hundreds of years distant from this, and a micro-percentage of Sephardic DNA did not make my white blood cells rebel. Nor did this minuscule amount of Yakut or Scandinavian consanguinity have anything to do with my daughter not being authentically Celtic.

At the time of writing this essay, my best friend's husband was dying. He was only forty, but a particularly virulent cancer that kept returning had eventually cornered him. Hospice staff are experts in end-of-life signs; they explain how extremities will grow cold as blood starts to leave the hands and feet, moving towards the vital organs. In the morning after his death, two days into the new year, I sat with her in the downstairs room where their bed had been moved to. In the first hours of her widowhood, we each held one of his hands. Artist's hands that had drawn the invitations for their wedding, which had taken place just eighteen days before. His fingers still contained a suggestion of heat. His heart had beaten its last; all those miles of blood had finished their cyclical journey. This is the body at the end: blood shift-

ing into something else. The final moments at odds with all the years and days of animation that lead to this moment. I had forgotten how, in death, the body hardens, how all that blood becomes solid, how quickly warm skin cools. I think of how our lifelong kinetic redness transforms in death. A final reinvention, a turning towards stillness, and away from the vitality in every living thing.

Our Mutual Friend

When people ask my husband and me how we met, we always exchange a look. At dinner parties, over luke-warm beers at barbecues, we know to catch the other's eye when someone asks. The question is a rope bridge between us, and both of us know not to sway it, or to glance down.

The look means one thing.

You know what to say, right?

After years of missteps, and people staring unblinkingly at us as we falter, we have learnt what words to pick. The story has been clipped and condensed; diluted to a hand-ful of well-chosen sentences, because the whole version is too much. It still has the power to hurt after many years. And these words, dark and difficult to say, can hush a whole room. So I rarely tell the full story any more, and never when my husband is there. Instead we offer one sentence, no explanations. Perhaps it sounds deliberately mysterious, but I take some perverse delight that it suggests the mun-dane, when this story is the opposite of that. But it works. People rarely probe further.

'Through a friend,' we say in unison, with smiles we hope are relaxed.

In the halls of the college arts block, the first thing I noticed about Rob was his height. The way he stooped to hide his stature, as all shy, tall people do. In a long-sleeved top with a wine trunk and mustard sleeves, he looked like a children's TV presenter. Fair-haired, serious, with a sibilant lisp. I mistook his shyness for arrogance, and steered clear.

Months later, we found ourselves on the same island. Every year thousands of Irish college students head for the East Coast of America in search of work. We were on Martha's Vineyard, a WASP-y idyll off the coast of Massachusetts. It was wealthy and quiet off-season, but in summer, the population swelled with students – like me – working two or three jobs. Days off were rare, nights even more so, but at a party thrown by other Irish students, there was this tall boy again. He was trying to retract his height, hiding his inches in the dark of a wooden hallway. We met up many nights after that, and bonded over music and books, eventually beginning a tentative, non-committal relationship. He confessed that he found the island suffocating. America had promised adventure but this place wasn't it. It had no pulse, and a big city further down the coast was calling his name.

At my twenty-first birthday party, he asked if I wanted him to stay on the island. The last year had been intense and distracting. I craved unpredictability, the sea, new people and experiences, and I didn't want to be responsible for anyone's summer but my own. So he took the ferry off the

island and went to Boston. The season unfurled, with its long work days and unexpected flings. One, a Johnny Depp twin, all bleached hair and blue crushed-velvet suit. The island felt ablaze. The heat of youth, the sand burning on South Beach, the rocks big and smooth as blue whales at Great Rock Bight in Chilmark. This was somewhere to be.

As summer ended, I made it to the airless din of Boston to see friends. I sat beside Rob on the steps of their walk-up, the humidity squeezing the breath out of our chests. The traffic on the freeway behind the house buzzed, insects swarmed around the trashcans, and he held my hand. That night we curled up on a mattress on the floor upstairs, listening to the city. The next morning, the heat already rising, I set out with an American friend on a road trip to Graceland. We listened to Elvis and smoked cigarettes non-stop, coasting across various state lines. Rectangular green road signs announced the names of well-known cities.

There is something about being either side of twenty that urges us towards independence. To hold on to a sense of self, being defiantly the person you are hoping to be, but are not quite yet. At some point, everyone feels an invincibility in being alone, of not needing anyone. In my early twenties, I was single by choice, mostly because I didn't want to fit the routines of someone else's life into my own. It wasn't just that, of course. The confidence I had lost in my teens, confidence in myself and my body, slowly returned. I was still self-conscious; worried about having to explain my physical self and all the ways my bones didn't work. But as

the distance between those hospital years increased, I was a little more at ease. That summer was packed with unfamiliar things. Pink hair. Infected sunburn. A tick burrowing into my skin. In Cincinnati, a man obsessed over my accent, asking for Irish words. The following Christmas, he came to Dublin and asked me to marry him. I declined.

Events move into the past so quickly, like an accelerated rear-view mirror, the lights fizzing in the dark until extinguished. The summer was over too fast and suddenly I was back to Dublin's autumn gloom, to my night job in a cinema, and to college, where I bumped into Rob again. There was distance, an uncertain kind, but not one born out of disinterest. Youth has its own absorptions; a sense of filling life up to the brim, of cleaving to some things, and allowing others to run through our fingers. We moved on different tracks for a while. I'd see his train in the distance, but we both freight-hopped and wandered on, figuring we'd meet again.

Becoming a couple happened accidentally. We circled each other for months. After an evening of conspiratorial chats, we ended up at the cinema. In the dark, I wondered what we were waiting for; why we kept each other at a distance. Afterwards we drank beer and laughed a lot, the hard edges melting away. I threw in my chips and rolled the dice.

College finished, we took the first jobs we could get, and then he moved into the tiny cottage I lived in without much discussion. There was barely space for one person, let alone two, especially one so random and chaotic as he was, so definitively undomestic. His turntables occupied

a corner under bookshelves, where he endlessly practised beat-matching and our record collections amalgamated. He could be thoughtful but immature. Acts of kindness were countered with feats of pettiness and laziness. At night, he worked late shifts selling gourmet sausages to drunk people in Temple Bar. Every weekend, he arrived home at dawn and fell instantly asleep in our single bed. His body a tired meniscus. Sleep was the only time he didn't stoop and his restlessness was at ease. His skin smelled of spices and the metallic tang of meat. For months we were happy. The future was out there, sometimes linear, but always unpredictable. Pockets of air and light, waiting to be stepped into. Alive with the possibilities of what we might do, what we *could* do, while we figured out which direction to go.

I always thought he'd be a writer. He carried a tattered hardback notebook everywhere. The spine had come away from the binding, but the pages were intact, full of passages and drawings. There were poems too, and he liked to recount how he once got talking to Allen Ginsberg after a reading in Dublin and was flattered when the poet clumsily hit on him. When Rob left Martha's Vineyard, I had given him my phone number on a scrap of paper, and later found it tucked among that notebook's pages. Back then – for reasons I don't remember – it was my habit to sign my name with celestial flourishes. The letters orbited by a moon, stars and a ringed planet.

Before we met, there was a college friend of his who drowned in a freak swimming accident. Whenever he

shared this story I could see its weight, how he laboured beneath it. It frightened him, the simplicity of being here one day, young-skinned and heart full – and then gone. At work, he called to tell me another of his friends had gone missing in South America, feared eaten by crocodiles after swimming in a river. Days later, her drowned body was recovered downstream, her intactness no comfort to her family. Around this time, one more funeral: a guy we knew who partied a lot and favoured pills. Somewhere amid all the endless nights and euphoric tunes, he tired of it and took his own life. Three friends, all connected to him, to that group of college pals. People noticed. Some talked about it. Rob brought it up, often late at night, fearful, sad, trying to figure out the why of it.

Few people enter a relationship knowing precisely what they want from it. Some things we have no knowledge of until we open the door on them. Rob was smart and funny and creative, capable of many things, but had yet to figure himself out. There were many brilliant days and nights: of talks, bed, parties, but after we'd passed the year-mark, I knew on some level that this – us – could not last much longer. The arguments increased, I tilted away from him gradually, and the distance widened. We parted after two years, but remained good friends, still swapping records and stories.

His youth felt like a scourge, even to him. The central modes of his life were contradictory: dedication to certain things – music, people, writing – but with a self-righteous sense of apathy. Dublin didn't fit him. It was too small – not

as minute as that summer island – but he craved the horizon. Everything was happening far away, and he wanted to be somewhere – anywhere – else. A few months after we broke up, he went to San Francisco, where he and his friend S shared an apartment. Rob's birthday was four days before mine, and that year a card arrived, bearing a painting of John Coltrane as a religious saint.

Another autumn rolled around and after they moved back from San Francisco, Rob moved into a flat with S, who composed music, produced bands and had a fondness for old synthesisers. Our friendships overlapped again, and there were nights out and house parties. We were a contented gang. The year felt as if it was moving towards something, for all of us. Rob had a new girlfriend, and was contemplating a return to San Francisco. S and I were mutually intrigued and interested, but wary of the triangulation, of upsetting the intersecting friendships. Testing the water, I confided in Rob about S, about how much I liked him, and that I felt there might be something in it. He had always been capable of grandiose snark, and a rarely displayed mean streak. Now, it resurfaced, almost with glee, and I have never forgotten his response: *It would never work. You're too incompatible.*

He was wrong, I knew that then. Felt it with every cell. Yet I was not at all surefooted as I picked my way towards S. There were many almost-times, at night, with others drifting by, when something passed between us, only to pendulum back to a safe place. When the conversation went

a certain way, when our heads leaned too close, we inched back into neutral zones, or talked of our mutual friend.

After months of circular complications, S and I finally got together on a Thursday in the summer. We talked all night, all day, unceasingly, unstoppably. Everyone should have one night in their life like that one. The next morning S-and-I were barely a day old but something had changed. I had no grounds for this, other than the possibility contained in all hours-old things. It starts with vigour and bliss, but then suddenly the world looks different. We parted reluctantly, with him homeward bound to the next county for a family party that weekend.

That Saturday I am working at a music festival. The loose arrangement I have with S is to meet up afterwards, when he returns to the city. I spend the day interviewing bands and wading through crowds. The sun gives up and slips behind the main stage, with music spilling from various tents. All day S is my only thought. I dial the number of his family home, sixty kilometres from where I am, to make a plan. The night spreads out. The last blue of the day turns black. I feel something that hasn't been around for a while: an electricity, a fizzing in the bones, that longing to see someone. *How did this happen?* I think. Someone hands me a beer. A colleague heads for the food stalls to pick up something for us. I'm content and it feels like the year has found itself; the weeks ahead are an open road. The phone at his parents' house rings and a smile turns my face to rubber. I think of what to say, how to be. The festival whirls around me, the lights

flicker, and a man who sounds just like S answers the phone. His brother says he has gone back to the city, earlier than expected. I know he doesn't own a mobile phone so I ask how to reach him, to find him later, alarmed for a moment that because of crossed wires we will miss each other that night.

– He was meant to be here, but he had to go back to Dublin early.

– Ah, OK. It's just that we're meant to meet up later, so I said I'd call. Any idea where he's headed, maybe I can catch h—

– Well, a friend of his had an accident.

– Oh no! What happened?

– I'm not sure, it was all a bit sudden.

– Which friend?

– Do you know a guy called Rob _____?

We ride the oldest roller
coaster in the world.
Its wood rattles so
we cackle to hide our fear
and the bruises that have
yet to appear.

I don't know why I asked the question about the friend, but I already feel a rising dread. The sentences keep coming, the call continues, my heart rate escalating. Talking from in the middle of a field to a person I've never met. Never have I wanted to forget a conversation more than the one that happened, but I remember every single word:

– What? Is he in hospital?

Words come faster now.

– I'm so sorry . . .

I really don't know what's coming.

– What happened?

This moment of before.

– I'm sorry. He's dead.

It can't be.

How do you line up words and put them in the right order, when you know they will never be adequate? That they are a flimsy version of everything felt in that moment. The world bends backwards, a sinister hallucination. I drop the drink in my hand. In a field full of thousands of strangers, somehow I end the call, howling into the dark. Primitive shrieks. I dial my parents' number and my mother later said that she thought I was being attacked. It felt that way. Assaulted with terrifying words. I recoil from this information, spiked with shock. Someone drives me back to the city and I eventually locate S, and the friend who was with Rob when he died. I have only fragments of the night, the story of what happened emerging through sobs and long silences. People sitting on the floor, keening and incomprehensible. Details emerge that are horrifying and senseless. A story so full of bad luck that it's hard to believe it could ever happen.

Rob accompanied a friend who was going to view a new flat. Adjacent was a tarred flat roof, and he climbed out, imagining it as a great stage for positioning turntables, the site of summer parties. It gave way, and he fell into the derelict building below, hitting his head on the way down. The

distraught friend tried to climb after him, at her own peril, and knew the moment she saw him that he was dead. Our collective grief is immense, but for her, the visual memory from that moment is terribly cruel, an additional burden.

What art did we see?
Picasso, Pollock, Georgia O'Keeffe,
The Temple of Dendur.
I bought a postcard
Nine Jackies, or Marilyn.
Our host has a wife now
Who met Warhol once.

There has never been a night like this in my life. Elliptical and strange, minutes not passing, people offering morsels of comfort when they had little for themselves. At some point I go home and the rooms feel like a place I've never been. Exhausted, wired, there is little in the way of sleep. I doze, and wake up in tears. I do this a lot. There are other unexpected bouts of weeping: in the shower, while trying to force myself to eat, on buses. I can sense the rupture in all our lives, the irreparable damage. S was the person who had to contact Rob's parents and has never got over that phone call.

At Fez, in New York,
the Mingus Big Band
Roll through
Haitian Fight Song.
We accidentally sit in
A booth reserved for

Our Mutual Friend — 79

Sue Mingus and
are asked to move.

On the last day of his life Rob didn't get out of bed until 5 p.m., a detail that has never left me. Would he have done other things if he'd had any sense this was to be his last day on earth? He couldn't have known, buried in duvet folds, that the clock of his life was counting down.

In Queens, we play house,
Care for a truculent cat,
Drink Sam Adams
With a Maths Teacher
from the Bronx.

My parents, S and I visit Rob's family. Their grief is enormous and distressing. Everyone is dazed. Screaming silently, making endless cups of tea. Grief is bewilderment. Grief is circling rooms and talking to unnamed relatives. Grief is a permanent headache and knotted stomach. Grief is sluggish time, staring at strangers on the street and thinking *how can you act like nothing's happened?* Grief is being angry that the sun is still shimmering away, smiling in the sky. We await his body's return from the undertakers, which will be laid out in his parents' house.

In a Boston club, Tricky is playing.
You dance on a podium to impress me.
We smoke in the street afterwards.
Exhaling American night air
That contains the glint of a knife.

For some reason, I expect him to be upstairs. Recuperating like a convalescent, as though just home from hospital or war, laid up with flu, or a bandaged limb. Someone steers me from the hall and with one swift right turn, there he is. (*Too soon*, I think, wishing I'd had the walk upstairs to prepare.) My legs go from under me, a mini demolition, and my mother holds me up. I notice an awful sound in the room, and everyone trying to stand still, all eyes turned my way. It takes a moment to realise the noise is coming from me; my mother squeezes my hand, urging me to keep it together. I don't know what else to do, how else to be.

Nightswimming in the bay
Bioluminescence beneath
You cannot swim
But wade in.
The black water
Illuminates.

The undertaker has dressed him in his favourite vintage shirt, one bought during that hot summer bussing tables in San Francisco. Underneath it, a maroon T-shirt I gave him, the top hairpin angles of the letter 'N' in VINYL RULES poking out. The ruffled faux silk of the coffin lining borders his bones. There are photos all around the room: the pudgy childhood smile, a teenage version sulking in a family group shot, the summer of bleached hair. A timeline that has now stopped, abrupt as an arrow.

Horizontal, eyes closed. He looks like him, just asleep. Long legs, boy hips, directional hair.

Rob.

But this is an unheimlich version of the man I knew. And his shoulder . . . That's what gives it away. I run my fingers over the joint, but the terrain is not the same. I know the swell of that clavicle, the drumlin of bone, which now juts strangely, broken for sure. I pull my hand away as if scalded. Shocked at this disruption to his body. They have made an effort to make him look symmetrical, composed, but then I notice it: the wad of cotton wool at the back of his neck, a pillow of sorts, too small for his head. Everything about it unnatural.

The room smells of formaldehyde and lilies. The summer heat amplifies their density, the harsh sweetness. That night, surrounded by candles, people wander in and out of the room to sit with him. There is such scrutiny in death. Our faces and bodies are looked at in a way people never regard them in life. Lines or freckles, the shape of nails. Things we don't notice when someone is still here. There are murmured prayers, chats in corners, lots of whiskey.

Because of the Beastie Boys
We hunt for Paul's Boutique
Even though we know Ludlow
Has been gentrified. You spend
All your money on records
In the first two days.

As there always is with funerals, there is a lot to organise, decisions to be made. Music was his obsession. His taste was varied and impeccable: Fela Kuti, Zappa, techno,

Ninja Tune, Orbital, Funkadelic. He owned the Muppets soundtrack and the recordings of Pope John Paul II's visit to Ireland. Rows of 7"s, Michael Jackson to Northern Soul. How could we possibly represent him in a handful of songs? A priest arrives to discuss the funeral and I know Rob would hate this. This man who never really knew him, cobbling together crib notes for a eulogy with no meaning, all pious insouciance. Rob's father leads us into a small room, away from all the mourners in the house. We begin, offering our suggestions, and his father plays a song by Bob Dylan, the singer his son is named after. He is heartbroken and the song amplifies just above the level of his quiet cries. When it ends, we gather ourselves, to offer him some words of thanks for this song . . . but the priest objects to it. This man who knows none of us, or how we feel, has made his decision. Even now, years later, it feels heartless and the reasons he gave escape me. S clutches my hand, a warning flashing on his face not to say anything. It was not the time, or the place, but this policing of grief was too much.

Another night, our bad camera
Picks out only you and me
On our host's roof.
Under electric city light
The World Trade Center
Is unphotogenic, immune.
They're now gone, along with you.
The photo is full of ghosts.

When we were a couple, Rob and I discovered many

musical overlaps. One was Nick Cave, and he bought *The Boatman's Call* for me in those first months, which we listened to on repeat. In bed all day, on shared headphones on a bus to Galway. It was one of the many albums that soundtracked our relationship. In the long history of album opening tracks, 'Into My Arms' ranks highly. With its implored chorus of guidance, of wanting someone you love to be safe, it seems to me like an obvious suggestion for a Mass. A song he loved, that had a shared meaning, one that hinted at the sublime and the religious. It's almost out of my mouth when I remember the opening line. I look at this priest, remembering his earlier dismissal, and am certain that he will not approve its context. That he will not hear what made it special for us. That he will veto it. *What to do, what to do, what to do.*

Someone presses play and we sit in an anticipatory circle, waiting for the solo piano to give way to Cave's sombre voice:

I don't believe in an interventionist God
But I know, darling, that you do.

Five notes pass and I decide that I will not let this man – a stranger to us and our sorrow – reject it. So I think quickly, and act accordingly. I fake a coughing fit and hack like a tubercular Victorian, all over those two gorgeous, declarative lines. Nick's voice fills up the room, in a song that pleads for non-intervention, 'not to touch a hair on your head'. I think of Rob's head lying in the next room, with

its open wound, his hair matted with blood from where he struck the iron girder during the fall.

Standing on a corner,
a skyscraper made flesh.
Yellow cab horns blare
And you feel at home.

That night, the house is quietened, down to the obligatory quota of close friends, relatives and neighbours. For the only time that night, I am alone in the room. Standing beside the coffin, I look at him. His quizzical face, problem skin, lisped mouth; his long body, a still hyphen. Someone leans on my back, and I turn to comfort them, but the room is empty. It feels as real as the weight of a person. I have no explanation. In the following weeks, this happens twice more when alone, and again at a Lee Scratch Perry gig. A gang of us go along to mark Rob's month's mind, the four-week anniversary of his death. The venue is half full, and while S is at the bar, I stand in a circumference of space, and, again, feel someone lean heavily on me. The nearest person is five feet away, and after that night I never feel it again. In a job years later, an unnerving colleague tells me I have 'a gift around newly dead people'. An uneasy inheritance from my grandmother and great-grandmother, something I am slightly reluctant to accept, or believe.

In a downtown bar
The flash makes an orb
in the mirror

The only photo of you
looking drunk
– but so happy.

The last day I saw Rob alive was my birthday, four days after his. A group of friends, including S, had celebrated him turning twenty-four, toasting all the possibilities in a Japanese restaurant. None of us at that table could have known that two weeks from that night, we would be gathered at his funeral, the sun beating down incongruously. Swapping stories and sipping beer with his family. When someone dies suddenly, I always think of what they were doing at that exact time a week ago. What they would have done differently if they'd known. Declare their love for someone, take shamanic drugs, fulfil a fantasy, visit another country. An accidental death has no schedule: one Tuesday, you're working, sleeping, laughing. The following Tuesday, laid in the ground, covered by three metres of soil.

How could you do all that you wanted to by twenty-four?
The door closing, the light gone, the sorrow of it.
But, tell me, were there moments, summer skies,
Birds threading notes, a last song at a party,
that made your heart soar? Was it enough?

Before Rob's death, I was already certain about S. Sure that we would be together. The trauma of what happened drew us closer, and we have remained together ever since. Those first months were intense and electric, but significantly blighted by loss. We may resist our *how-we-met* story,

but it is the story of us, despite how bound up it is with sadness. This new thing that came to be has endured, and without our beloved friend, it would never have happened. Our son has Rob's middle name and we talk to our children about him. I regularly speak to his oldest sister, who was a teenager when he died. The world turns and another year passes without Rob in it. All the places he never went, the sisters he never saw grow up. I had never known him to be ill, ever. His body was resilient until the catastrophic fall. Our lives all went on, but his was recalled, over in a moment. Perhaps there is another ending: a parallel life where he fled the country; not gone but somewhere else. I imagine him back in San Francisco, promiscuous, making music, smoking on a fire escape. I see his tall spine moving easily across Haight-Ashbury, weaving up and down those hills, ducking under the Bay Bridge, and out of the city lights.

On the Atomic Nature of Trimesters

It is a truth universally acknowledged, that a woman in possession of a womb and a decent supply of eggs must be in want of a child. We know this, us women. The directive that every one of us must produce or will want babies even predates the Virgin Mary miraculously birthing Jesus Christ (without the prerequisite fuck). The urge to procreate and propagate is as arbitrary as any other act of free will, but has been imposed on women like so many other ideals of womanly perfection. Be thin! Be beautiful! Be pregnant! The entire concept is predicated on biology-as-destiny, as though the acme of being female is to be a mother. But not everyone wants to be. Not every woman has a womb, is able to conceive, or has instant access to semen. The assumptions about what female bodies are, should be, or can do have progressed, but the expectation of eventually choosing motherhood has persisted.

There are many terrible things you can call a woman. These terms have their own poisonous corner in the glossary of 'woman slurs'. We know these words, with their harsh consonants, are the favoured insults. Their genital

etymologies are meant to remind women of their function and worth in relation to men.

Unmaternal. It's un-ness implying its oddness. To be un-something is to be the opposite of it, at odds with it: that *un* is unnatural. 'Childless' is another word. Women who choose – happily, with no burdensome thoughts – not to reproduce are cast as unloved loners. Self-absorbed harpies. Bald-headed Roald Dahl creatures that want to torment children, not bear them. A lesser kind of woman. As though the only way to express caring and kindness is to create – or parent – another human being. Enter any female celebrity's name into an online search engine and the word 'children' invariably follows in the auto-complete search options. It starts early, this message that girls should be nurturers; that emotional labour in life is unavoidable if you identify as female. Dolls – those pseudo-babies – are a right of passage, and each one I owned was perambulated and lullabied, their permanently pursed mouths shushed, their plastic limbs bathed and dressed. One doll endured an experimental haircut, and post-scissors looked like Poly Styrene from X-Ray Spex. Amid all the booties and bibs and fake bottles that refilled when turned upside down, motherhood must have flashed before my eyes. It wasn't a singular moment of *there!* freeze-framed on a screen, 1980s VHS-blurry. Somewhere along the line, I must have thought that I would be a mother, mostly because I liked the idea, not before I realised there was an expectation that women should follow through on this pre-destination.

I am an only girl, born in between two wonderful

brothers, but growing up the longing for a sister persisted past my mother's fertility window. There was pleading, begging, offering-to-mind-it supplication for her to have another daughter. During the decade when my brothers and I were all teenagers, it was only me who was cautioned daily about coming home with news of impending parenthood. Warnings about lives ruined, prospects gone, the physical jolt of being left holding the baby.

In our twenties, post-college, pregnancy was the last thing I or any of my friends wanted. A baby was akin to an albatross. A dead-weight barrier to dreams and jobs and travel. Friends who had children at the time are now out the other side of parenthood. They are free. But back then, children were considered a faraway land that some day we might dock at the pier of, marching down the gangplank to look motherhood right in the eyes. Those decades of youth were also spent figuring out the body, listening to it, swimming in its cycles. Warnings about not getting pregnant were constant, but no one talked about how our bodies actually worked, the good windows and bad, how to navigate our own fertility in the time before period apps and ovulation sticks. The entire concept of ovulation was hazy, our own wombs mysterious to us. It wasn't until actively deciding to have a child that people talked in hushed voices about cervical mucus. How crucial it was, in all its egg-white consistency. The conception equivalent of ambergris.

I did not pine for a child when I was younger. It did not inspire longing, unlike the lure of US highways, or faraway time zones; but I back-pocketed the feeling, tucked it away

for later. Even with studied carefulness, most women will have a pregnancy scare. Days of checking and waiting. Our biological lives are numerically driven; twenty-eight-day cycles (a rarity) and a two-week wait before peeing on a stick. Then the fork in the road: if this was the desired outcome, there were the excited nerves of waiting to hit twelve weeks before announcing the news. Or the other option: an unplanned crisis with horror-struck calculations: tallying of dates, totting up the cost and realising its incompatibility with one's financial situation; the decision – until very recently in Irish history – to travel to another country that offered reproductive rights.

It is natural to put our faith in our bodies. To trust that they will be ready for the task when we are. Life is lived in the present tense; calendrical from paycheck to period. Every woman assumes that they will be able to get pregnant – until they can't. There is one attempt, then three, and the months roll by. Friends talk of nasal sprays and self-injecting, of countless internal examinations, of no heartbeat, of *go home and take the drugs.*

A woman is born with all the eggs she'll ever have. I had never thought about this until my lungs were gurgling with a clot and tubes were being inserted into my body. I was twenty-eight. Science decreed that I was in the middle of the optimum fertility window of 20–34. I imagined myself on a *Tron*-style grid, a small curve on a maths graph, an oscillation. Thinking myself responsible: I was on the pill and assumed that there were still years left of avoiding pregnancy. But then it is 6 a.m. on a cold Sunday, still dark

when the ambulance arrives. I am diagnosed with blood cancer and someone tells me that chemotherapy will start tomorrow. Everything always starts on a Monday. Working weeks and new beginnings and the rest of my life will start on Monday. The first full day of nothing ever being the same again will be a Monday. In this rush of twenty-four hours I have one recurring thought (not death, because I can't allow myself to think about death). My eggs. *What will happen to my eggs?* All those ova I've steadily bombarded with artificial oestrogen and progesterone all these years.

When the doctors intimate that there may be a chance of dying, time both speeds up and stands still, becoming a precious commodity. I am told calmly that there is *no time* to freeze the eggs, for what doctors call 'oocyte preservation'. In my body, the bad lymphocytes are trying to kill the good oocytes. At this time in Ireland, there are no preservation facilities for eggs.

When the bad news lands, I experience a flash-forward – of the children I won't have. I avoid dwelling on the cancer horror that's unfolding, so I think about the eggs. I attempt a calculation. How many I have, how many I've used up, all those years of menstruation, all those months of relief. I imagine them as white, then red, then clear. I wonder if they are ovate or ovoid or elliptical? The latter, perhaps. My fertility as the open-ended question of an ellipsis . . .

Will I have children?

. . .

Am I infertile?

. . .

How did life end up here?

. . .

As well as the shock and the bags of blood and the vomiting something that looks like blood, there is another drug. This is not the pill, but a variation on it often used with HRT or to treat other gynaecological issues. I am a clot risk, from a non-pill clot, and the consultant prescribes Norethisterone. It is similar to the body's natural progesterone, which can suppress gonadotropins: FSH (follicle-stimulating hormone) and LH (luteinizing hormone) – all the hormonal elements a woman's body needs to make a baby. Like illness, pregnancy has its own vocabulary, of things you never knew existed, or there were even words for. This drug can also be used – in my case – to inhibit ovulation, and for endometrial transformation (which makes me think of a gaudy makeover show, a curtain pulled back to reveal a patchy womb lining now sleek, shiny and swan-like). I wash down these pills to quell my ovaries, and a baby becomes an impossible feat. There is no blood for close to a year, which is unnerving. *This must be what pregnancy is like*, I think, listening to the night sounds of the hospital. Nausea, no bleeding, life-altering bodily changes: they both mimic and are the opposite of pregnancy. There are new, unfamiliar cells growing inside me, multiplying and dividing, but they are not a baby.

After six months of chemotherapy and complications, the doctors declare remission. A gynaecologist tests my hormone levels and likens them to those of 'a post-menopausal woman'. Her secretary phones when I am driving. I pull over

and cry on the hard shoulder of a motorway. Out the other side of cancer, I am also nervously embroiled in maintenance treatment, involving three different kinds of medication. One is ATRA, the drug that has saved my life, and only works on my specific type of leukaemia. It is extremely costly, and each time I return to order another batch the pharmacist exhales softly and raises a sympathetic eyebrow. The capsules are unremarkable but there is a legion of expensive toxic damage contained within their plastic casing. Along with two other drugs, I take nine of these a day for fifteen days, every three months, for two years. In total, I ingest 1,080 ATRA capsules. The side effects are numerous. Headaches, which were rare for me, now arrive with eye-blinding frequency, due to 'benign intracranial hypertension'. My skin is always dry, shearing off in mini blizzards. One of the more unusual side effects is an odd kind of visual disturbance. The source could be retinal or corneal, but for months I see odd shapes in my visual field.

Two years of ATRA and maintenance pass (with one complication, connected to Ireland's then draconian repro-duction laws), and I am closely monitored for relapse. The prospect of having children felt too difficult to think about while recovering. A baby was not the first craving, like post-surgery ice chips, or a meal after days of illness. Because of the ATRA, all proffered advice suggests waiting at least six months before trying to get pregnant. I wait longer.

My body feels in limbo, getting better, but still very much in the medical world. Mentally, there is a weighing up

of what has happened and what it means. The road ahead will be long and there is no way of knowing the outcome of continued remission. In pregnancy terms, the statistics are against me. There is one certainty: after years of surgery and waiting rooms, wards and curtained-off beds, I know I will not try IVF. I have reached my limit of invasive procedures. My body needs a rest. *Enough*, it whispers. My husband is fine with this, and we decide to try naturally, nervously. The decision to have a child should be so joyful, so *fun*, but to us, it is so daunting. I am filled with fear, not wanting to be disappointed in myself, to feel my body fail again. I push these thoughts away.

My birthday is in summer, on the eve of Lúnasa, an ancient Celtic festival that prays for a good harvest in the autumn. Earlier in the year is Imbolc, the feast of St Brigid, associated with fertility. I turn thirty-two, ready for whatever happens. Motherhood has become something else. A state that I think about and try to ignore. Its abstractness long gone, as it hovers around my life. Eleven weeks later, there is a faint pink line on a test. An illusion. Then another test, a more expensive one, with words not lines. The wait for the results fills up the room. Eyes move from sink to bath to floor, anything to anchor on to. This is not joyful anticipation, or expectation, this feeling. It is familiar. The same as the one experienced when waiting for bad news.

And then *Pregnant* appears in the tiny window.

There is so much disbelief, not just then, but in the first few weeks. As though I've pulled off a huge hoax, fooled my body into giving me something I longed for. I have carried

off a heist, jumping into a getaway car, leaving alarms and sirens blaring behind.

I wait for something bad to happen. It is always peripheral, like the rotating swastika side effect in my eye, this waiting for my body to mess up. My bones, my blood have form, they have done things they weren't supposed to. I convince myself that even though my body is now attempting to do something that most women do with ease, I will fail. I can't let myself believe it and am too afraid to tell anyone.

Right at the time that this new person is growing inside me, my mother is being treated for cancer. There is chemotherapy and surgery, and she is in and out of hospital. I long to tell her, but don't want to worry her, or put her through disappointment if this does not work out.

Now that it seems to be happening, the urge to be a mother is insistent, and in those first few weeks, I'd do anything to guarantee it. Sell everything I own, make Beelzebubian pacts, donate an organ. And I know then that if the whole experience ended today, or next week, or before I get to thirty-nine weeks, I'd never be able to lose this urge. To go back to not wanting a child.

At seven weeks, my obstetrician insists on an early scan. This tiny thing – a clump of cells, a pink line on a test – is too small to show up on a pelvic ultrasound, so the scan is transvaginal and a wand – that's the word used – is inserted inside my cervix. This is the part where I am meant to believe in magic, or invoke the occult. The screen is a blur of layers and shapes and it's not until she smiles, and calls my husband in, that I notice I'm holding my breath. She

points at something minute and says *there is your baby*. I allow myself to fully access the feeling. To fill myself up with it. It is utter joy, in its completeness.

The urge, with good news, is to share it, but we are too nervous, not wanting to tempt fate. Each day passes, a clash of savouring the feeling, of willing the weeks to clock up, knowing that the baby is getting stronger. After the tests comes the fear. Life is about to go off road, and nothing will be the same again. And what do you do with such a tiny being?

On the day of the scan, I enter one hospital and my mother is discharged from another. The last two months have been relentless and good news is sparse. It's late November, and she is at home propped up in bed. We visit, saying we have an early Christmas present for her. Sitting on the bed, I hand over the blurry image, a thin square of shiny, photographic paper. She stares at it, trying to figure out what it means. Then there are smiles and tears. She berates herself for not guessing, but she has had a lot to deal with. At Christmas, it will be twelve weeks and we can start to tell friends.

The weeks progress and there is no sickness except for a diabolical nausea every morning unless I eat. Tiredness that hits like someone bashed me over the head with a brick. I crave sweet things and bake brownies, eating trays of them as quickly as I can make them. The early kicks, a fish bumping against the glass of its bowl. I appear on TV and a friend's mother says, so casually, *even your fingers looked fat*. Strangers have an opinion on the pregnant body: whether the shape is huge or neat, if it's a boy or a girl, if your breasts

are more pendulous, if your hair is shinier, if you are – a sac-charine state – 'glowing'. Everyone says with a concerned head tilt that *you're overdoing it*. People you would not share a spoon with place their hands on your stomach, oblivious to the intrusion. The pregnant body is not solely its owner's domain. In gestating another person you become public property. The world – women in shop queues, neighbours, the internet – is full of unasked for comments and advice.

The months stack up without incident. The scans, which are regular to keep an eye on things, have nothing to report. A sonographer lets slip the sex at twenty-one weeks, but I already knew it was a boy. My body, which I have learnt not to rely on, does everything it's supposed to do – until the very end. Three weeks before the scheduled C-section, I see my doctor, and, on the walk back across the car park, a strong pain creeps into my lower back. Instead of lying down, I drive to B&Q, and in a fit of nesting, buy shelves and paint. The pain lingers, a series of aftershocks. As the rumble in my spine persists, I remind myself this boy is not due for another twenty days. That night, my husband makes me laugh and it happens. Waters gush and I drip an amni-otic trail up the stairs. We dash into the night, forgetting the hospital bag, knowing that he is on his way.

From laugh-leaking to birth, the whole experience takes less than three hours, and there he is. The cry as he emerges from the crescent of my body is the most real sound I've ever heard. A unique note, a song between us. There is sur-prise, gratitude, relief. In the hours after my son arrives I throw up all the opiates I'm given and cannot stop looking

at this tiny boy. The pulse of his fontanelle, the pink of his perfectly formed limbs. His hands coiled like a secret. This is what every mother does, and has always done. Basked in the newness, this never-before. Of him, of the dawn, of the feeling of being someone's mother now. The drugs pull me from nausea to exhaustion, but my eyes refuse to close, not wanting to miss a minute of him.

In those first days, someone comes to check his hips. The old unease, the wait for *everything's fine*, takes even longer with him. I realise it will always be this way. My pelvis – over-operated, much drilled, bone-shaved – has pulled off a pregnancy. It holds fast until a year later. When my son is nine months old – the length of a baby's gestation, crawling and grabbing and curious – I find myself in the same bathroom, with the same black-worded declaration in a small plastic window. This has not been planned. I am overcome with shock, and with sheer luck. It is hard to believe that my body has bounced back. After all that I have asked of it, it responded. In one afternoon I go from shocked tears to bliss to the same old fear. There will be two babies in two years. *Please stay, please be OK*, I say.

No two babies are the same. Pregnancies too. I am barely a year older, but the obstetrician suggests a nuchal fold test, which leads to another test. Fifteen weeks in and I am lying on a table as a man plunges a giant needle into my stomach. The procedure has a 1 per cent chance of causing miscarriage. It feels like a horror film, watching myself through my fingers, trying to disassociatively observe the scene from

above. The results take two long weeks. The whole fort-night is anxious, even my son's first birthday party. I smile and pass cake around. A phone call finally confirms that all is fine, and because this has been about chromosomes I ask what the sex is. A rustle of paper, the muffle of a phone held between chin and shoulder. *It's a girl.* Being pregnant at all feels like a miracle. I have never had a preference about the baby's sex. Two boys would be fine. But she will be a she. A girl. Our daughter.

Things go as they did in my first pregnancy, until pain starts in my pelvis and vertebrae, settling itself in, a squatter in my bones. After nearly two decades, I am reacquainted with crutches, shuffling back and forth to the maternity hospital for physiotherapy. The physio is sympathetic, but has to press harder, to dissipate the knots that spasm around my hip's shattered hull. I go with it, and do that silent kind of weeping women do in hospitals, while she works deep into my muscle tissue, leaving dark, angry bruises for days afterwards.

In pregnancy the body is a vessel of cartilage and sinew, of uterine layers. The corpus (more religious connotations), the main body of the womb, carries its fragile cargo, a ship crossing new straits. Salt on the skin, saline in the veins. This pregnancy starts to resemble drowning. My lungs are bad sails, refusing to fill with air. They slump, not billow. Doctors conclude that the problem might be heart damage, caused by the earlier chemotherapy, but after tests – more wires and screens and measurements – nothing conclusive is found. The only evidence of this pregnancy is the weekly

photos of my growing stomach that my husband takes. The thriving bump at odds with my disintegrating hip. If I recall this pregnancy at all now, there is not a moment devoid of pain, and of pounding physio. Of craving oranges and citrus, of flaming heartburn, of twisting pillows under my joints as I chase sleep. Those months were to be endured, not enjoyed. Never have I been more aware of the calendar, of days passing, of watching the clock.

The pains start on a Sunday and when they wouldn't stop, we drove to the hospital. 'You are not in labour,' they said. I'd experienced contractions when pregnant with my son, enough to know differently. Briefly I am back on the usual merry-go-round of making representations on behalf of my own health. After eventual admission, I lie in a room with five other women. A young woman, late teens maybe, so thin all over, her belly a disproportionate cauldron. An older woman with multiple children; a young Latvian woman who talks non-stop on her phone, a flat-lined monologue, the sort New York cab drivers have via Bluetooth for an entire fare, to someone on the other side of the world.

Day turned to evening, and I roll in the bed, gripping the sheets like a life raft. My husband fetches a nurse who again insisted, 'You are not in labour.' I distract myself and think: *What does your face look like?*

I talk to our daughter between contractions: *I'm here. You'll be here soon. I can't wait to meet you.*

Later, in the dark, the six trace machines beeped, answering each other. One woman is wheeled away, wailing, and I know there will be no sleep. Nearer to midnight, the pains

gear up. The only relief is to walk the corridors, clinging to the walls. Hospitals are lonely. Despite the bustle and noise and non-stopness, it's not hard to feel alone. It is worse at night, when the day clinics are closed, all the visitors gone. No one passes me on these walks, soundtracked by shouts and moans, the click of monitors and drips, the lights from phone screens blinking behind curtains.

'Are you OK?'

A young nurse notices the path I've worn out, the repetitive circles I'm moving in. My obstetrician, who is out of town, miles from Dublin, is phoned and says she will drive back through the night. The due date is still a month away. My daughter and my body are about to part ways. The bones have had enough, and I wonder if there were whispered negotiations. *Could you leave early? This isn't working out.* What I know of my daughter now, with her kindness and empathy and ready-for-anythingness, is that she would have politely agreed. Maybe even smiled, before steeling herself and launching out into the world.

A nurse administers a steroid injection to help speed up the growth of her lungs. I phone my husband, who is sleeping, and tell him to come back to the hospital. Later, on a trolley outside the operating theatre, I call him again, suspecting (correctly) that he'd fallen back asleep. *Please hurry.* She is four weeks ahead of schedule. If something goes wrong, I don't want to be on my own.

Spinal block, hospital gown, doctors working at the other end of me, over the fence of surgical sheets. The best sense to rely on here is aural. My body is half numbed, the lower

half uncommunicative. I can't see over the screen, or past the swarm of medical staff, so I listen, as though waiting for birds at dawn. Straining to hear her first cry, the indication that she is here, and she is OK. With C-section babies, you hear them before catching a glimpse. A pair of hands pushes down heavily on my stomach, a rolling sensation. Pressure, tugging, and then she is lifted up and out into the world. Crying into the surgical air. Her colour is worrying, and two nurses rush her to the other side of the room. They busy themselves with masks and tubes, and bring her back after what feels like days. I am allowed to hold her for less than a minute, and then she is gone. To the floor above, the sea of plastic boxes in the neonatal unit. I spend her first night in the world without her. A nurse takes a photo and brings it to my bed, and because I'm morphined up, I alternate between crying and vomiting. I nod off for only minutes at a time, to crazy, narcotic dreams. Later, my husband wheels me to the lift, an emergency plastic bowl on my lap in case of guerrilla vomiting. Under the lights, her colour shifts. Eyes closed, she looks as though she's concentrating hard, working something out.

Microchimerism occurs in pregnancy when cells from a foetus move through the placenta, binding with those of the mother. Babies are born and leave a trace, a cellular contrail. They remain inside us for life, burrowing deep into marrow. I am moved to know I will always carry a part of my children inside me. I also know I will never do this again. My body is done. Stomach and womb stitched up, like the binding of a book. A new seal will show up soon. The joints

have taken a battering, and somehow will have to be fixed. My body is further away from the pristine thing it was when I was an infant like her. It depletes and declines, and yet it gave me these children. Whenever an image of the difficult months ahead appears, of negotiating with orthopaedic doctors, I look at her face. The tiny pulse in her neck and the soft seams of her eyelids, shut tight against the world.

Panopticon: Hospital Visions

There is a chance that you entered the world in a hospital. First cries ringing out beneath stark lights. Emerging from under the blue sea of your mother's surgical gown. At once subjected to the medical gaze. Weighed and watched, doctors listening for a sign that says *I am here, I live, I breathe*. The snail shells of bunched fists jabbing at air.

The hospital's hulk squats over many hectares. Inside, the layout unnerves: white mazes, sharp right angles and endless corridors. The patient is a minnow, navigating streams between the X-ray lake and the reservoir of outpatients. Crossing the borders of cubicle, room, ward, corridor.

While working on this piece, a medical issue arose. *Another one?* I think, never surprised by the ease and regularity with which a body can falter. I stall and take painkillers, I stall when the swelling won't abate; I stall until I know I cannot ignore it. The GP dispatches me to the ER of a women's hospital, the one where my children were born. Admitted,

cannulated in pink and purple (when did medical tubing get so girly?) and intravenously treated until surgery the next day. *Is there a chance you could be pregnant?* An obligatory question before treating any woman. The pain doesn't stop, getting incrementally worse. Explaining the actual sensation is like attempting to describe an individual experience of having children, falling in love, or grief.

Trolley-trundle and siren-blare. *I'm on lates this week.* Whirr-blink of machines. Food trays rattling. *Nuuu-rrsse!* The three notes the blood pressure pump sings on completion. Pinging of patient call bells. Squeak of sensible footwear. The pneumatic door hinge opening and closing like bellows. The ghostly exhalations of those who took their last breath here. Hospitals are rarely silent. In 2013, Brian Eno composed '77 Million Paintings for Montefiore', a piece composed for a hospital in Brighton. It was, perhaps, an attempt to combat the medical hum, to obliterate the cacophony of that space. A generative piece, it changed and evolved, playing in the hospital reception. On another floor, a longer work, 'Quiet Room for Montefiore', was also broadcast, intended to promote healing, or replace the standard hospital soundtrack: movement, vending machines, visitors, the sound of other people's suffering.

In a top-floor room, there is a source of consistent, broken tapping. I assume it to be birds. *That's THE bird*, a nurse

explains. *A fake bird on a string to scare off other birds.* Eternally in flight, its carbon fibre wings bouncing off the flat roof. I try to find a rhythm in each landing every time the wind drops.

The air conditioning goes unnoticed by me for weeks. Until it appears like tinnitus, and the rattle becomes an anti-earworm. Nurses and cleaners tell me they can't hear it, but it thunders through every night. The tell-tale heart beneath the floorboards, the woman inside the yellow wallpaper.

Do you hear that? The haematologist addresses the student doctors ringed around my bed, a white-coated picket fence. *A clot sounds like a creaky door*, he says.

When they leave, I listen for its hinges.

Hospitals are not unlike galleries. Interactive spaces; a large-scale installation of sound and colour, evoking emotion and working on the senses. The art on the walls here mixes modernity and old votives. State-funded canvases alongside Sacred Hearts and religious statues. On the longest corridor, the hospital's spine, black paintings hang at clockwork intervals. Abstract, inked, their form and meaning unclear. I look down whenever I pass them. *Bit depressing, aren't they?* says the porter pushing my wheelchair.

After her daughter spent time in an orthopaedic hospital in the 1940s, British artist Barbara Hepworth met the surgeon Norman Capener. Hepworth was better known as a sculptor, but Capener invited her to sketch and draw operations over a two-year period. In ink, chalk and pencil, Hepworth captured not the gore and invasiveness, but the work of fixing the body, of surgical intervention. Hepworth claimed that both careers had similarities:

> There is, it seems to me, a very close affinity between the work and approach both of physicians and surgeons, and painters and sculptors. In both professions we have a vocation and we cannot escape the consequences of it. The medical profession, as a whole, seeks to restore and to maintain the beauty and grace of the human mind and body; and, it seems to me, whatever illness a doctor sees before him, he never loses sight of the ideal, or state of perfection, of the human mind and body and spirit towards which he is working.

New day, new cubicle: the woman in the next bed speaks conspiratorially into her phone. *My urine was clean.*
I TOLD YOU.

A curtain is not a door. Confidential consultations hang in the air, a murmuration of medical words. A swallow swoop

of numbers and percentages. Someone on the other side speaks Russian – doctor or patient? *Spasíbo*, they whisper. *Thank you.*

An opinion piece by a doctor appears online, about the overcrowding problem in Irish emergency departments. Hospitals are over capacity because patients have been 'decanted' into emergency departments. It's an unusual choice of word. Patients compared to fine wines, their bodies filtered into the cut-glass crystal of casualty.

In the women's hospital, the nursing staff, mostly Filipino and Irish, are attentive and kind. They are paid considerably less than doctors. *Why are there so many men in gynaecology?* I ask one. *It's the highest paid field in medicine, so . . . money.*

If, as Le Corbusier states, a 'house is a machine for living', what is a hospital? A machine of another kind, maybe, but one that contains nothing of the domestic. A warehouse sprawl of technology, temporarily housing people, but devoid of the familiarity of home. It is a panopticon, where there is little privacy, and the patient is always visible in some way, if not always actually seen. The hospital is a place of necessary quarantine where control must be abdicated. Inside, there are risks. Of not waking up post-anaesthetic,

infections, encounters with MRSA, the hail of germs from sneezing, tissue-less visitors. The overly solicitous chats from the stranger in the next bed.

The air. *Can we talk about the air?* The coagulation of smells. Other people, cleaning products, distant hot-plated food with no singular tang. The metallic, surgical dregs of something disappearing. Vomit. *Inhale.* Hand sanitiser. *Breathe.* Disinfectant. *Exhale.*

(Too much? The patient has not embellished.)

Michel Foucault writes in 'The Birth of the Clinic': 'For classificatory medicine, presence in an organ is never absolutely necessary to define a disease.' Without the X-ray, we do not see the hairline fracture, without the ultrasound we cannot witness the weeks-old foetus, without the MRI we miss the lesions. Doctors seek signs in the moons of nails and the whites of eyes. Illness and pain do not require a physical manifestation to be real.

The Uzbek anaesthetist in the women's hospital asks pre-surgery questions, so I roll through my complicated medical history. In theatre, waiting for the spinal block to take hold, he talks about his country. It is 'very corrupt' and doctors get paid €200 a month. To prosper, they must take bribes,

which he refused to do. *I left because I do not think money and medicine mix.*

This place of sutures, incision and surgery is called a theatre. No curtains of heavy velvet, but instead disposable blue or green. The stage is a table, a Greek *ekkyklêma*. Every player performs, except the passive patient. Lines to guide the surgeon are drawn on the body, a crude *commedia dell'arte*.

Hospitals are a dominion of streets and mapped lines. Their psychogeography filled up with each body that has passed through them. *How many people have slept in this bed?* A commonwealth of wards, a confederacy of the sick. Anyone who presents themself for care, cure or examination must accept the role of patient, which requires them to give up something: freedom/free will/free movement.

Hail the body's own geography, what Foucault calls 'the anatomical atlas'. Latitude tendons, longitude veins. The textured terrain: soft rind of skin, rope hair, sandpaper stubble.

Doctors replaced clergy as healers, but medicine and religion remain heavily intertwined in Ireland. Hospitals and wards bear saints' names. Ethos and doctrine complicatedly

bound up in the 'Catholic country' that failed Savita Halap-panavar. How many lives lost, how much care withheld, because of religious intrusion on the realm of the body?

This may not be war, but there are two sides. The well and unwell; doctors and patients; staff and visitors. Susan Sontag wrote of the dual kingdoms of the well and the sick; one passport stamped, the other with the corners cut off. Illness gives us permission to drop everything – jobs, commit-ments, the tangle of repetition that is everyday life – but the price is high. Hospital requires a packed bag, but no ticket. Instead of yellow islands and turquoise shallows, there are rectangles of blankets, beds instead of sunloungers.

A patient is not a person.
A patient is a medicalised version of the self.
A patient is a hospitalised double of the body.
To become a patient is an act of transmutation, from well to sick, liberated citizen to confined inpatient.

There are hundreds of ways to break a leg; no two breast cancer diagnoses will have the same topography. My cancer is not your cancer; my fractures are not yours. Illness, despite its classification and language, is as unique to each patient as their fingerprints. It is not generic; it resists homogeneity.

It is not solely about biology, but intersects with gender, politics, race, economics, class, sexuality and circumstances.

Questions/suggested opening gambit:

What's wrong with you? Illness equals wrongness.

Where does it hurt? A request for specificity.

Do you have health insurance? Capitalist enquiry.

Is the doctor–patient exchange a dialogue, a conversation or an interrogation? It is an encounter in triplicate: verbal, tactile, textual. Text has legacy and permanence, unlike speech or touch. Our medical narrative is contained in the clipboard hanging on the end of the bed, or in the coloured cardboard folder. We repeat our story to multiple doctors and the file swells, in different handwriting, a collaborative piece of text, a diagnostic round robin.

Hospital truncates consciousness. Time operates on a different level. Meals appear randomly, outside the usual milestones of the day. Thought becomes cyclical waiting for the next administration of drugs, the next ward round, visiting hour. The clock crawls through the night; sound and light interrupt. Conversation is rare, reduced to a handful of haikus between temperature checks.

Infarction. Presentation. Pyrexic. I have learned their language, picked at the bones of their syntax. *Marsupialisation.* The

most important part of such an interaction is not to listen, but to ask. *GA or spinal?* Because I have made frequent enquiries about my health using the medical words that belong to my history, it has been assumed by doctors that I am one of them. This has an implication of its own: that a patient's motivation for being invested in his or her own health is transgressive. To be curious, or to possess such knowledge, is not your place. My assimilation of medical language – of inverting the act of questioning – has always been an attempt to assert autonomy; to hold on to a small part of my medical story.

Before pale blue tunics, nurses wore white dresses with upside-down watches. Starched hats with coloured bands that were a declaration of authority and hierarchy. Blue, green, red; but black for staff nurses. A funereal band as though in mourning. The hospital palette is infinite. Primary and pastel squares on the colour chart of urinalysis. Pink ketones, green proteins, beige bilirubin. In the phlebotomy clinic, lines of phallic test tubes with vaginal lids, hermaphrodite and colour-coded. White doors for electrical equipment, green emergency exits, biohazard symbols in bumblebee black and yellow. The red line on the floor that leads to the cardiac lab. An artery of red duct tape, the untaken brick road in Oz. Parts of the tape are missing, the broken line of a margin.

You are always far from the exits. But at least this is temporary: as a catheter, a paper stitch, the gypsum cast covering a bone.

The cardiac ward has blue curtains, pleated and dark. I try to find a word for its specific shade and settle on Yves Klein blue. His blue was an invention, and surprisingly recent, given the longevity of eternal blue things – sky, sea, eyes. The shade complements the pale gown the nurse has instructed me to wear. *Put it on so that it opens to the front* (pause) *like a coat.* Her voice is matter-of-fact, and professional, but there is kindness too, almost imperceptible. Patients are so attuned to these small gestures. They matter. In the last decade particularly, hospital protocol has undergone a perceptive shift towards empathy, including the introduction of the #HelloMyNameIs hashtag. To patient-centred care that recognises that a body in a bed is not just a diagnostic predicament or a hospital number, but an actual person with fears.

After two days I left the women's hospital and went back to this piece. Life and writing had been briefly interrupted by the body going off course. Before I left, I took a photo from the hospital bed and a week later it appeared alongside these words on the wall of a gallery. The evening light made the bed sheets look like snow peaks, the blue curtain resembled a paint-ragged sky. As in any picture, there is no sound,

none of the chaos that I know lurked beyond that curtain. It is an almost peaceful scene, recalling the kind of quiet only experienced at altitude. The composition and colour were an unexpected kind of calm, and in that moment, so rare in such a place, I had felt that it would all be OK.

The Moons of Motherhood

I

They arrive at night, my children. Pulsing into the dark, entering the world when the moon is up: a new moon on the day my son is born, a waxing crescent for my daughter. After that first night my daughter and I were apart, the second night is spent attempting to feed her. The US election results roll in and the blinking light of the wall-mounted TV keeps us company. Across the ocean, there is hope. States declare themselves blue and Barack Obama is about to be elected. In our small room, all I can do is stare at my new daughter. There is possibility in every molecule of her and tonight, in the world too.

During long nights and noisy afternoons in the hospital, I start to learn things about her. She does not like the bath, she falls asleep easier than her brother did, and she eats very little at a time. Her small belly can only handle minuscule volumes and although her intake is consistent, in her first days, she nearly chokes. Before we are allowed to go home, a nurse insists that all babies must demonstrate that they can eat a certain amount. I explain her incremental appetite,

that she was born early and in ICU, as the nurse forces the silicone teat of a bottle into her mouth.

The comma of her body uncurls, her skin darkens and she goes limp. The nurse whips her away, holds her upside down. With my daughter hanging bat-like, she thumps her back, shouting commands. I watch in horror, stuck to a chair. The sound of those slaps, her body turning purple, the feeling that after all we've both gone through for her to be here, she is slipping away. Sore, panicked, afraid to move, I am watching someone else's life, not mine at all. It takes a minute – too many seconds – before she cries and I grab her back from the nurse. The baby and I are both upset, the nurse oblivious. 'You can go home now.' And a fear, familiar as night, creeps in. That the implicit trust we put in the medical world has been misplaced.

My hospital experiences have been good and bad, and childbirth is no different. Both births were medical and invasive, had more in common with surgical procedures than birthing pools and timed breathing. I had wanted natural deliveries, but my fused hips made it a dangerous consideration. They were no less births, and I did not feel any less of a mother. Only other people make you feel like that.

With second babies – even small, premature ones – staff assume that mothers have got this. That you are a matriarch pro who knows exactly what to do. Second-time mothers are deemed wise as monks. Yet I felt like I was starting all over again; that this child was my first, even though somewhere else in the city my sixteen-month-old son was dreaming his

way through this moment. We were discharged that night, safer at home than in the din of the hectic maternity ward.

The memory of her suspended by one leg has never left me. My skin chills even now. It is imperative to replace this image with something else. Thetis holding Achilles above the River Styx. Maybe this act, this first encounter with trauma, has made her immortal, inviolable. *She will be invincible*, I think.

After my son was born, I had to inject myself with a syringe of heparin, an anticoagulant, for six weeks. Every day, between finger and thumb, I pinched the skin on my stomach, angled the needle and jabbed it in. It was best done quickly to alleviate the sting. Heparin is said to be 'relatively' safe post-pregnancy, in that due to its large molecules it does not cross over into breast milk. Hundreds of drugs have sluiced through my body, many of them highly toxic. It plays on my mind, the reason for my breast-feeding hesitation. I worry that putting anything into my body changes it, taints it. One possible side effect is HIT, or heparin-induced thrombocytopenia, a severe syndrome that can cause stroke or heart attack. In some cases there have been limb amputations. My caution does not feel misplaced but I cannot decide. I try talking to a nurse, who responds with a scold. 'If you don't, you'll regret missing out on that bond.' I had not anticipated this urge to undermine women right after they'd carried another person for nine months, expelling them in what can only be described as a gruelling act of attrition. Yet it is also easily criticised. You gave birth, but it wasn't natural; you gave birth, but you had a spinal block;

you gave birth and now you're not breast-feeding? The casualness with which women are berated is never surprising. Our best efforts are not enough, and those unconnected to our lives can be so keen to remind us of it. Naturally this is done with that most passive aggressive of oratory tricks: faux concern.

Two days at home and I am back in the hospital with a womb infection. I have not been able to eat and the sonographer comments on how empty my stomach looks on the scan. I have to wear compression stockings, which require Herculean effort to roll on. They pinch and leave mesh marks. They and the heparin are keeping my blood in check. But with this new person in my arms, everything is about life. There is no room to think about death. One dark morning, my son is unsettled and memories of my illness return. There is my husband, parents and siblings, but only I gave birth to him. Before, when I was ill, and not a mother, it would only have been my body that would be gone. Now he is here, utterly dependent on me, and death would not be the isolated incident it once was. Dying would mean parting from this days-old person, and in those early weeks, when my sleep-addled brain races, I think about this. The horror of leaving this infant, whom I barely want to leave the room without. I start to imagine that if I died when my son was six months or one or two or three he would never know me. My husband would show him photos; I would make iPhone videos, or write letters to be opened at significant milestones. Every time I have a check-up, this feeling returns. Motherhood reinforces my mortality. I am

not allowed to die, not while my children are small, or not ever. I cannot do that to them.

In the hospital after his birth, my mother held my burrito'd son and said to me: *Now you'll know.*

That now I'd finally see what she meant.

About what?

That everything was leading up to this. That no responsibility in life was more important. That I would understand everything my parents had gone through.

Now you'll never stop worrying. For the rest of your life, you'll always worry about him.

It was a shared moment, a passing of a generational torch, but felt ominous. Was this parenthood? That every second of joy would be atomically split with fear? To bring a person into the world is to introduce them to all the fear and struggle, all the potential hurt and horror that can assail them. They will realise, one day, that they and everyone they love will die, so they must seek out good things: joy, people who make them laugh, songs. In those early days, I could soothe their sleeplessness with holding and rocking, but also by singing to them. Whispering choruses and rhymes into their ears, spreading notes across their skin.

We were in this together, each child and me. Inexperienced, feeling the way along some ancient passage. I waited for booby-traps, poisoned arrows, a giant boulder to flatten me. Just as there is a before and after with illness, so there is with children. During pregnancy, people gleefully shrieked: 'Sleep now! You'll never get a full night's rest again!' Often, these heralds were not parents, and yet they spoke with the

same conviction, as if they'd paced the floor hundreds of nights with a wakeful child. The whole experience feels like being lost at sea. The uncertainty, the sleeplessness, the disorientation, a rhythm that is both steady and unpredictable.

You do not need this whole story. The story of each baby, growing, turning from newborn to toddler to child. You do not need nappies and bottle rinsing; or constipation and sugared water and figs, as the small balloon of his belly expands; or the knack of collapsing a buggy; night feeding and teething. That my son would never, ever nap, so I drove around aimlessly, hoping the engine would lull him; that he resisted a Moses basket as though it were a coffin. The flushed face drool of teething. The time I turned away for one second and my daughter rolled off the bed. The soft cotton of their little chests rising and falling, but checking in at night to see that they were still breathing. The paraphernalia and equipment, otherwise known as 'the stuff': high chairs and travel cots and sterilisers. All that plastic with padded corners. All that safety, and despite it the feeling that protection only goes so far.

In the first weeks, time bends, hides inside itself. Motherhood is living in that new sense of time. Being home with an infant is both static and non-stop. The days are long and short, endless and blurry, and yet there is always something to do, even when they nap. In a bubble, I don't leave the house much, or sleep, because while my husband works, it is just me and the child, the child and me. It is our cave. The clock looms only to indicate feeds and naps. I never manage to get dressed even though I am a patchwork of baby vomit and

milk stains. My stitches sting. The books – which everyone scoffs at but reads diligently – say that mothers intuitively know their babies' language, that they learn what each cry means. It's a short checklist: hungry, tired, wet or full of wind. The weather forecast of this newborn. Meteorologist is another role I take on; so is translator. Not sitting at the UN, headset on, but climbing the stairs and walking the rooms, cradling a child. Trying to decipher my son's messages, what he is trying to communicate. Morse dots, baby cries. I try to interpret: why he arches his back, why he will not sleep, why he stares the bluest eyes into the green of mine. *What are you thinking, Baba?*

Knowing how to be a parent is not instant, and each of us grows up being parented to various degrees. The rules change, no two children are the same, and no one really knows what they're doing. Parenthood is cumulative, a gathering of bits of information, bundles of sticks to build a house . . . (The whole world outside is the big bad wolf, to strain that metaphor.)

Although they are tiny pink flesh machines who sleep and expel fluids and cry, they are canny. I know he knows me, knows that we were crammed together for nine months, bodies touching. He knows that I am his mother. He follows my voice around a room, the way an animal responds to sounds in the night. He absorbs all around him, clocking these examples of how to be a human. While his mind is expanding, mine contracts. My brain feels as though it is constantly trying to sneak out a secret door in my skull.

Something happens to memory. Even now, I have to ask

myself: was it after his birth or hers that X happened, or Y occurred? In the past, when I acquired other significant objects – a car, a home, jobs – the experience was vividly recalled, all events either side of the *moment*. The first months of parenthood roll by and there are home nurse visits, vaccinations in clinics, the first time leaving the house, carrying all 'the stuff', terrified. In this recollection there are few details. Nothing about dates, except what the calendar dutifully informs me of. A new phase under a dictatorship, a tiny benign autocrat rules all. In the night, listening to his sucking milk gulps, I imagine tanks rolling onto our street.

Children veer erratically from massive dependency to rogue strikes out on their own. They know nothing and everything. I marvel at their smallness that contains so much. Organs and bone all in miniature. One day, a glance up and there they are: expressing preferences and offering opinions. Time has transmogrified: the accidental iTunes fast-forward that turns everyone into staccato cartoon singers. Clipping moon-slivers of baby nails to stop them scratching, then watching the same hands carry a too-heavy rucksack, crossing schoolyard tarmac. The feelings coalesce: sadness mixed with relief that they are at this point and you have managed not to break them. Returning home, the house is desolately empty, but that quiet – *Oh the quiet!* – means work, and words. I learn to co-exist as mother and worker, mother and writer. A person who can be cave deep in words and the second they are needed, closes the laptop or puts down the pen, summoned to the cot, the garden, the school.

II

The problem with motherhood is that it is so rarely divorced from parenthood. For mothers, parenthood is more than just the state of being a parent, surpassing the reductiveness of nine-month gestation and the credit-roll denouement of birth. Birth is merely the beginning of an eternal commitment to the demands of nurture. After breast or bottle, after nestling into the new groove carved by something that came from inside us, there is responsibility.

A woman's life is often inexorably directed towards the making of a child. Historically, fertility was as valuable as wealth. Barrenness was marginally less socially ostracizing than being a spinster. Today, the anachronistic idea persists that a woman is not fully a woman until she is a mother. This is another spoke in the damned-if-you-do, damned-if-you-don't wheel of patriarchy. Personhood predates motherhood. An individual exists long before having children. This is perhaps what causes a distinct recoiling in me when other women, who happen to be parents, say, *As a mother*. As a mother . . . what? Growing two babies in my uterus did not bring with it Solomon levels of wisdom. Arguably I am now less wise than I was without children. My edge has been slightly sanded down, along with some of my freedom. Conversely, I am better with time, that thing that morphed and changed like a horror-film spook with their arrival. To still be yourself, the person you were before becoming a parent, is both an easy continuation

and difficult to transmit. Somewhere in between there is a recalibration.

Press *hold* to stop time (me, always).

Hold to press skin (me, in the dark with you).

The conflict between mother and individual, mother and worker, mother and writer, became quickly evident. Freelance work life resumed eight weeks after my son was born because of financial necessity. When he slept – a rarity – I would frantically write 150-word album reviews, which was the limit of all I could ask of my brain. Desperately trying to remember words to describe guitars and choruses. I wasn't a writer yet, which eased one responsibility off my shoulders. This is not an acknowledgement of trite terms like *baby brain* or *momnesia*, but a sense that words were lost to me. That it would have been impossible to gather up thousands of them, enough for a book's worth. To shape and swap and arrange them into something coherent.

Personhood, Parenthood. The words swim into each other. The immersive first years settle and then the self pulls away a little further year after year. One autumn, when they are both at school, I sit at an antique desk, looking out at beech trees and the dark grey of a lake. The late afternoon shifts. I am bunkered down at an artists' retreat that is landlocked and remote, two hours from home. I first applied and was offered a place here two years before this moment but could never make it happen. Now, I attempt to put one word in front of the other, while looking out at a lake. As I face into the 3 p.m. slump, a comment floats up out of nowhere.

'But what about your *kids*?'

It was said casually, of course, when I explained my intention to go away to write. Now it was amplified: not only had I abandoned my children, but here I was in the Irish countryside *having notions* about writing. All creative urges were instantly replaced by maternal guilt. The audacity of me heading off alone. The added implication being that my husband is incapable of minding our children solo for a handful of days.

This enquiry, as we are all well aware, is based on several gendered assumptions: that women are the primary caregivers, and that writers (really, men) need their unchallenged space to write big, important tomes. At arts festivals, moderators ask women who write, without a jot of awareness, about 'the juggle', while male authors, looking serious, stare off into the distance. On the same panels, in libraries and marquees and town halls, no one turns to the men who write books and enquire about childcare arrangements, or the wives and partners who step up to facilitate their writing.

Every night at the retreat the guests – writers, composers, artists – sit down to dinner. Someone observes that only the women speak about their children, and of supportive partners holding the fort. One woman, an artist, admits that she had loaded up the freezer with pre-made dinners so her husband wouldn't have to cook for himself. Only the women around the table debate the conflict between finding time to create and fulfilling parental obligation. Every one of us delighted to be here, to be without demand or

expectation. To power down motherhood, and throw up the switch on writer. There is an affable male poet, also escaping his day job, who says he always sleeps for his first two days here. I am here for five days. Every second will count. I cannot afford two days of sleeping instead of words.

This abundance of time and space is new to me. I am not used to writing for nine hours, and my concentration regularly dips. In one trough, I read Zadie Smith's essay 'Find Your Beach', a meditation on city life, which also explores her overlapping roles of mother and writer: 'My lovely children who eat all my time, the books unread and unwritten.' I read 'F for Fone in the *Winter Papers* journal, where Claire Kilroy writes that motherhood has made her life 'an angry few years [. . .] Writing used to be the answer to all my problems [. . .] but now I can no longer write.' Everyone who writes, and has children, can relate to these blood-and-guts stories of creativity and priorities. Of longing for headspace instead of playdates, and feeling guilty for it. The writer protagonist in Jenny Offill's novel *Dept of Speculation* is caught between wanting to be 'an art monster' and her role as a mother. She bumps into an editor she once knew, who says casually that he must have missed the publication of the character's second book. When the writer explains that there isn't one, he asks kindly: 'Did something happen?' 'Yes,' she says firmly, downplaying the fact that her writing has been sidelined by the circular loop of motherhood.

You do not have to be a writer to relate to any of this. Offill's words chime with every parent – those who commute

to work and those who stay at home to raise families; those in factories or offices, in schools, shops or labs. *I feel this too*, we say. *This is my life.*

Virginia Woolf, who was far removed from the work and grind of daily life, made generations of writers think that they're entitled to a room of their own. At home, my desk is in a room full of books, read and unread, that sit next to Lego and other various toys. Our lives push up against each other. There are hundreds of sentences in this book written when my children wander in to chat, or tell tales on each other. Their voices echo all over the house and it's impossible not to tune into it. I can focus, but my daughter's songs carry, as do my son's conversations with the dog, in that voice he saves just for this creature. But still I go back to finding words and fitting them together. I start to see the shape of what I'm trying to build, word by word.

III

In the kitchen, my daughter is dancing to a song. Later, in the shower, her voice filters down the stairs, note-bending impressions of St Vincent, Adele, or a rotating cast of tween singers. Various FIFA soundtracks have brought Major Lazer and Tune-Yards into my son's life, a bonus for me. Together, they watch TV chart countdowns, squabble over number one predictions. They ask me to take them to music festivals that they are much too young for. Their lives are full of music, but that started a long time ago. For some,

memories are invoked by smell or images, but it's music that always performs some sort of alchemy, or archaeology, on my brain.

Recently, I heard Ms Dynamite's 'Dy-Na-Mi-Tee' again and relived one November day, when it had been playing on the car radio. I was newly pregnant, and my husband was driving us to our son's first scan. In the passenger seat, tears welled up and caught me off guard. Crying mostly out of fear, of being told that once again, my body would not be up to the task, ambushed by something bad and unexpected. In the dim light of the consultant's room (we are never more vulnerable than when we're lying down) I was fully ready to hear awful news. But there he was, boldly circling the screen like an aerial performer. Months later, in the dome of my belly, he turned somersaults at a Joanna Newsom gig, as did his sister at Kraftwerk a year later (the fact that she was 'there', and not him, still causes spats). Every time I hear that Ms Dynamite song, I think of him, and that terrifying scan, and – after so many years of health complications – how much we wanted him.

When we finally got to meet him, he was a tiny insomniac. I played songs to soothe him – Amiina, Sigur Rós – rowing his buggy back and forth like a boat on the waves. He and his sister have grown like trees, through their many music phases, picked up by osmosis: The Ramones, Beyoncé, Vampire Weekend, lots of hip hop, Kendrick Lamar. My heart burst the day my son asked for 'Wuthering Heights' on repeat. Now, older, they're finding their own musical tastes. Figuring out the beats that tap on their soul, the harmonies

that weave in and out of them, the rhythms they floss and dab to.

Milestones arrive with alarming frequency. Every time something new develops in them – height, unfamiliar words, the discarding of once-loved toys that are now 'for babies' – it feels like a little loss. My son walked to the shops on his own for the first time recently, and with it, another premonition of him eventually out in the world on his own. Whenever these changes come, fast as a bullet train, it feels as though everything is shifting too quickly into the past. That I will have to let them go a little further away from me every year. That my protection is finite, and the years are moving forward with cosmic speed.

Another milestone arrives in the shape of their first big gig. Tickets have been bought for Justin Bieber and for weeks before the event, they ask to see those white paper rectangles over and over. A month before, many children are killed at an Ariana Grande show in Manchester. There is collective incomprehension at all that optimism and youth obliterated. As infants, children learn that music is safety and security; that sung words and melodies are as protective as a wall. Now they're becoming aware that there are people who want to shatter that normalcy. They have lots of questions about Manchester. It is hard to talk to people you love about an act of intentional hate. We get ready for Bieber and they ask why we cannot bring a rucksack for the treats they've carefully selected. I mutter about the heat, and crowd safety, because who wants to mention bombs on a night full of such smiling anticipation? We drive across

the city to the venue and I realise it is the same one where I saw my first big gig (R.E.M. on the Green Tour with The Go-Betweens as support). In the throng, my daughter nervously regards the crowd size, but is transfixed by the older girls around us. They start to dance, and shyly she copies their moves, punching the air, gasping at the fireworks. Teen girls could rule the world, with all their energy. So much effort has been put into outfits, tans and complicated face sequins. I watch these girls, who adore each other, elated and confident, roaming the toilet and ice-cream queues, all swishing hair and linked arms. My daughter watches them forensically, a longing to be one of them etched on her face. Wishing to be here with her own friends, not her mother and brother. In every one of the girls, I see her in six or seven years' time.

Music binds us together. It is a centre point of life's key events – birthdays, weddings and funerals; it consoles us when someone stomps all over our heart; it is the source of spontaneous dancing with friends (as a kid, or when you're older, after much wine). And pop, perennially scoffed at with its sugary vibes and Auto-Tune, has much to offer, especially when seen through the eyes of those with so much love for it.

Nothing can trump the vitality and possibility of young boys and girls watching a singer they revere. Music is a constant in times of uncertainty and chaos, a needle on an eternal groove; offering communion, connection. It is being under the lights when a thousand phones held aloft look like a galaxy of stars; feeling the thunder rumble of the bass in your chest; buying a band T-shirt and wearing it until

it falls apart; counting the hours to school the next day to tell your friends that you were there, because you were: collective voices singing on the breeze of a still-bright school night. This is the first of many gigs, of sharing the night with strangers who love music as much as they do.

IV

Music is the reason my children used to be obsessed with death. But only death in the abstract sense, when it was something that only happened to famous people, not those we love. Until Terry, or my best friend's young husband. It transpired that their interest in the subject was not about the ending of a life, but of someone not being here any more. They began to ask constant questions about people from history, from music, from the films we watched together. They found it reassuring if someone they'd just discovered was still somewhere in the world, inhaling and exhaling, travelling, working, writing songs.

Is Elvis dead? Is Willy Wonka dead? Is Michael Jackson dead? Is Mary Robinson dead? Is Stevie Wonder dead? Is Bill Clinton dead? Is the guy who sang 'Video Killed the Radio Star' dead?

Is David Bowie dead?

Until January 2016, I was able to say with breezy relief that Bowie, in all his heterochromic glory, was still with us. They were very sad when he was not.

Conversations about religion are complicated. My husband and I are not religious. Our children are not baptised,

and are fine with this, but religion is part of the school curriculum. We answer their questions, teach them to be respectful of believers, and do not sway their opinion. One day, they may believe and we will support that. Not long after my son had started school, he declared out of nowhere, with a Nietzschean fervour, 'I think God is an eejit.'

And they ask about heaven. I have no knowledge of a place I don't believe in. Instead, I talk about the night sky, swapping theology for astronomy. I present them with stars in place of Stations of the Cross. On my phone, there's a star app, which we point at the sky in search of planets and celestial bodies. The city lights frequently obscure the view, but the stars always show up on this screen, technology undeterred by cloud cover. We tilt and roll the app, looking for the Big Dipper, the Seven Sisters, the flattened W of Cassiopeia. With the little I know, I talk of supernovas and quasars. In Italy, on a mountaintop, the four of us watch a blood moon rise, with Mars hovering close by. They'll grow out of this soon; of thinking their parents have all the answers. They will realise the size of the globe, begin to dream of all the places they'll want to see. The stars will be here long after all of us, I tell them, wherever we may go. I cannot speak for heaven.

The Haunted Haunting Women

I see women coming over the hills, walking down into the towns and cities. Pulling coats with missing buttons tighter, balancing babies on worn hips, saving pennies and counting cents, not shaking off the boss's hand when it lingers too long, the multiple jobs, or work turned down, rounding the corner with a buggy only to find a flight of steps, criss-crossing the supermarket aisles with *stop, stop, stop asking me*, wiping noses, and undrunk, cold cups of tea, pristine kitchens, lives without a spare minute to stare at the sky, fury simmering in their heads.

I see one woman in particular. All the moments of her life piled up like bones. The countless actions, the days of her youth she recounts to us, a drip-feed of her past. In the midst of all those addresses and moods and cigarettes, all those sighs and each-way horse bets, she is embodied by two things: weeds and ghosts.

It was spring, and in the back garden, my grandmother pulled up dandelions from the lawn. There were never any flowers in this garden, save for this unwelcome yellow. Tearing up roots, pulling 'piss-the-beds' from the soil. My grandfather records that she walked back into the house,

leaving the sunshine over the coal shed, and just collapsed. They'd shared a bed for fifty years and he knew her breathing, each rise and fall of it, but he'd never heard her breathe like this. A not-her, pneumatic snore. My mother arrived and her brain, flooded with panic, dialled 888 over and over, wondering why she couldn't get through. Why there was no calm, factual voice saying: 'Emergency Services – which service do you require?' At the hospital, a doctor declared it a catastrophic heart attack. That morning, she had smoked half a cigarette, extinguishing it with her bare fingers, for later. As the paramedics worked on her, the upright blackened butt looked down from the mantelpiece.

Towards the end of a person's life, it's said they become more rooted in the past, gravitating towards the beginning of their life as they approach death. In the weeks before her coronary implosion, she talked constantly of her parents. 'I'm going home,' she kept saying. I read about Hades as a child, and the River Styx, and whenever I think about people near the end of their lives, I am assailed by this image. I see her climbing into a small boat, sailing across the water to her parents, clutching an oar in her crabbed fist.

Apart from holidays on the ferry and day trips to seaside towns, the only place she visited outside Ireland was England, its rain and gloom a mirror of the weather she'd always known. This sudden focus on looking backwards, the historical gaze over the shoulder, led to talk of adventure: of wanting to go somewhere, or explore a new place. So shocked were we at this sudden declaration that we never

thought to ask where she might want to go. I suggested flying somewhere, anywhere, Earhart-ing it to Europe, because in her seventy-two years, she had never set foot on a plane. She did not own a passport. She liked coastal towns, but there were no Rivieras or Costas in her past. Perhaps she knew time was short, and was playing along, knowing that she wouldn't have to fulfil any promises made.

She always told ghost stories. Not the ones about spooks and banshees, or bogeymen who'd grab you in the dark, but the ghosts she knew. 'You should be more afraid of the living than the dead,' she said, in any situation, whether it called for supernatural advice or not. I knew she meant her father, but she took her time telling us the story. My mother still tells it, my aunts too.

He worked as an insurance collector, but because of his height and demeanour, people assumed he was a G-man, a Special Branch operative working with the RIC (later the Dublin Metropolitan Police, now called the Garda Síochána). He travelled around the city on a motorbike, and one afternoon, while out on his usual rounds, he swerved to avoid a child and hit a lamppost. He was badly injured, but clung on for three weeks in a coma before dying, leaving my great-grandmother, Mary, a young widow. She had four children and was pregnant at the time of the crash. Part of the overlapping ghost stories in my family includes an oddly prophetic line her late husband often said to her: 'I'll never leave you with a young baby.' Grief triggered a miscarriage, followed soon after by the death of her youngest boy. She gave birth to ten sons in her life, and only one

grew up. What kind of quiet is there in a room after a baby stops breathing, or never takes a breath at all? I wondered if she ever saw their ghosts, an almost football team of infant boys, lined up in the shadows.

Her daughter, Veronica – my grandmother – did grow up, and perhaps too fast. Hers was a fitful life, steeped in poverty and bereavement, a grief that became fear, and later, a nervous breakdown at eighteen. She was convinced her mother would die and she and her two siblings would be alone.

No matter how nuclear or fragmented a life is, everyone fears its annihilation: the death of a parent, pre-deceasing a child, the arrival of illness. The events that are unutterable, those incomprehensible moments, the ones that happen to other people. The terror of these things, even the brief imagining of them, was enough for my grandmother. She lived with the ever-present possibility of it, and that was enough to darken her life. The family lived in the back room of a tenement in Dublin 8. To survive, my great-grandmother delivered babies and washed the dead. Ushered people into this world and out of it, souls clean as a blank page, others heavy with a lifetime's weight. She had a second job as a weaver, spending hours on a loom, and would leave the tenement room to go to work, locking the door to keep the children safe.

That's when he'd appear.

My grandmother always started the story from the key-in-the-lock moment. The sound of her mother's footsteps

retreating down the stairs, and the feeling of being left alone for the day. The first time her father appeared, my grandmother screamed until the neighbours fetched her mother back. His appearances became a regular thing: her mother would leave, and he would stand there every day until she returned. It took my grandmother a few days to realise what he was doing: standing guard, keeping watch. She got used to him, or this post-death version of him, showing up, but her siblings never saw this apparition. This ghost as protector. He looked so real she could tell the colour of his coat (a brown Crombie).

This psychic seam is in my family, a running stitch on the matrilineal side. My great-grandmother also claimed to predict the future by looking at someone's hand of cards in a game. In the dim light of the tenement floors, large families lived in just one room. Sanitation was hazardous, space non-existent, so young men would gather on the stairs, in a ring of huddled shoulders, to play poker. Wandering past one evening, she glanced at the hand dealt to one young man.

'You going somewhere?' she asked.

'No!' came the incredulous reply.

'Your cards say that you're sailing. You're going on a boat.'

He laughed in her face, and she went on up the stairs to her children.

Because this is a story I've heard so many times, and this is what happens in our inexplicable world, I can tell you this: the next day, he eloped to England with a girl. His

mother banged on Mary's door. 'Would you have believed me if I told you?' was all she could offer the woman's reddened face.

On the landing below the room they lived in, my great-grandmother sometimes saw the ghost of a British army soldier. His green/brown uniform identifiable even in the lightless tenement staircase. Her husband – before the child on the road, before the coma – had served in France in World War One. He came home, but millions didn't. Silted up in trenches, the red snow of poppies over their remains. This man on the landing was not familiar, but Mary was unfazed by him. Perhaps he was a comrade, a messenger from somewhere else to reassure her that her husband was OK.

Púcas
 Headless horsemen
 Haunted roads
 A dancing couple near the Grand Canal
Ghost nuns
 A red-eyed black cat
 A woman walking through a hotel wall
(People tell me they've seen these.)

Irish history and folklore is rooted in stories of spirits and malevolent beings. We don't do voodoo or juju, but we soak up stories of haunted souls and feel the dead walking among us. We talk of keening banshees whose mournful song foretells a death, witches who transform into hares,

lonesome selkies out at sea. In hard times, the Irish told stories, floated words over candlelight, passed winters going from house to house, a tale on the lips. Tales that are in every sod and brick, an ectoplasmic mortar. The old tradition of waking a dead person has been revived, and with it the idea of weaving a narrative of the departed's life. Those mournful nights are for those who are left behind, bereft. The worlds of the dead and living inch nearer to each other. Stories are swapped as an act of resurrection, but for comfort too. Words can keep the memory of anyone alive.

'Have you ever seen a ghost?'

What is said and what is felt when this question is asked are at odds. There is a fear of the answer, but no one wants it to be 'no'; to reverse back down the conversational cul-de-sac. We crave the affirmative, a chance to suck in breath and wait for what comes next. 'Yes' is an opener: a signpost at the entrance to a wood, urging us to walk into the gloom of the trees. There are two questions I am often compelled to ask people: if they know their blood group or if they've ever seen a ghost.

Not being able to have the life you really desire creates a spectral longing for another existence. A ghost life – of opportunities, travel, a career – running alongside the one being lived. One life of no choice and little variety predicated on economic circumstance, the other free of material

constraints. Society dictated that women born in the first half of the nineteenth century, especially those not lucky enough to be middle or upper class, were allocated a very specific lot. There was little in many of these lives. Scraps of education, which stopped at twelve, or maybe fourteen (this has happened to all the women on both sides of my family). Marriage, babies, a life in the home. In the hierarchical structure of the family, the Irish mother managed to occupy the top slot while holding the least amount of power. The central figure expected to contribute so much, but was rarely repaid. When I think of our history, these are the women I see. The unseen, rage humming in the air. Their lack of choice a collective lament.

My older brother baulks at the intersection of the spiritual and paranormal. For him, there is no life after death; our bodies are bequeathed to subterranean creatures to feast on. But he cannot explain why he has prophetic dreams, or sees things beyond the realm of the scientific. He can see auras. Ghosts too.

The cottage he lived in – one bedroom, outside toilet, and, in winter, frequently colder inside than out – was built in the 1890s by the Dublin Artisans' Dwellings Company for workers at the nearby Guinness factory. The windows were small, the house always dark, the winters especially so. One night, my brother woke to find an old woman sitting on the end of his bed. He went through the motions – rubbing eyes, pinching skin, performing all the usual rituals

to confirm wide-awakeness – but she was still there. When he described her to the elderly lady next door she said without hesitation, and as if this was commonplace: 'Oh, that's just Annie.'

I do not know if it is possible to come back from the dead. And if it is, back from where – heaven? If we reject Judeo-Christian allocations, perhaps there is some other autonomous land in the clouds, a municipality of eternal life and good health. If such a place exists, and this journey is possible, it must be a long one. Climbing through stratospheres and exospheres, all that air and all those chemicals, clawing the way back, a mountaineer with a hammer. But is this return from some unknown realm an act of ascent or descent? Religion and philosophy and poetry have largely informed the thinking on this, cheerleading the presumption that this place is heaven, and that it is located vertically above us. If it were easy to come back, would every dead soul not attempt it, even once? For one last look at the life they are no longer a part of, to see their children's faces once more, or walk the yellow fields of youth?

'Annie' was the previous tenant in the house before my brother. He says she looked like a real person, solid and contained, almost bemused. 'Were you afraid?' I ask. 'No. She just seemed curious, about who lived here now.'

To my grandmother, the dead were benevolent, the departed effigies of those we love. No one could dissuade her of what she'd seen. She was adamantly, devoutly Catholic, with its inherent belief in heaven, but to her, the world of spirits was just as convincing.

She once visited me in hospital after more hip surgery. Post-anaesthetic, I vomited with the regularity of a traffic light. *Red, pause, green, puke.* The nurse inflated a cuff on my arm, timing my pulse and counting in her head. My grandmother, watching, took in the scene, waiting for the right moment to brazenly ask the nurse to check her blood pressure too. I don't remember the result, or the nurse revealing its fractional outcome. Maybe it was already too high, her heart sending out early signals even then.

In another hospital, twenty years earlier, my grandmother's youngest son had a complicated operation on his spine. Afterwards, things were touch and go. In the murk of night, tussling with sleep, the post-op drugs entering and exiting his brain, he opened his eyes. There, impeccably dressed, stood a man beside his bed. He knew who it was by the coat, the hat. Pure hallucination from the depths of a medicated haze, perhaps, or just a trick of the light. But this was the hospital my great-grandfather was taken to after his accident, and also the same ward. In times of illness, the body and its vulnerability will take anything it can get, even a manifestation of someone long dead come to watch over us.

Ghost stories are unheimlich; exaggerated versions of things we know. A familiar person or entity becomes something strange and frightening. A home becomes a haunted house. A keening woman is a terrorizing banshee. But to my grandmother, there was comfort in these spirits; their presence offered solace.

I was seventeen and home alone when I found out that she had died. A friend of my mother's called to sympathise, not realizing I hadn't yet heard the news. The shock made the whole house feel instantly cold. Illness had not been hovering at her door; there was no family rota of hospice visits. No one had expected this. Confused and in tears, I waited for my mother to come home from the hospital, and the day slowly turned to darkness. Her heart, that windmill in her chest, had stopped turning. Her children did not want her to stay overnight in a funeral parlour, so her body was brought back to her home. The home with the scullery and dandelions; the bad couch and the bathroom off the kitchen; where she was laid out in the bedroom she'd shared with my grandfather. Candles burned and mirrors were covered in white cloth. Someone wove rosary beads into her waxy hands. This was my first encounter with a corpse. The marbled skin, the hardness of a once-soft face, the ice in the veins. Below the room where she lay hung a photo of my grandparents from not long after they were married. In the coffin, with her 1940s curls, she looked more like this younger woman. The undertaker had done *a lovely job*, someone said. The pink lipstick was an anomaly: I'd never seen her wear make-up. All the lines on her face were gone. The years of her father's death and tenement life; of stillborn babies and ECT after post-natal depression. Wiped clean with the stopping of her heart. In life, there had been a brashness to her, a quick temper – but she had suffered, and her manner was a form of defence. It was hard to connect the older version of her that I knew to the nervous girl

of her teens. The girl so haunted by the possibility of the death of loved ones that her mind caved in on itself.

✳

'Have you ever seen a ghost?'

I ask myself this, or you ask me. Either way the question is asked. The answer is both yes and no. But it is the wrong question. The line of enquiry should be both more accurate and broader – a contradiction:

'Have you ever encountered a ghost?'

The language of ghosts is a visual one. Floating, ethereal, see-through. Visualization as definitive proof. The I-saw-it-with-my-own-eyes validation. So I say, yes I have *encountered* a ghost, but I haven't *seen* one. No ghostly form, no indistinct edges, but I've felt their hands, their weight on my skin, more than once. As though another living person with flesh-and-blood limbs was touching me. Tactility is not the same as visibility, but it has its own veracity.

In the months after my grandmother died, my grandfather started to say things about her death to me. Very specific declarations.

'If your nanny is going to appear to anyone in the family, it'll be you.'

The basis for these words was never explained, and I didn't understand the logic of me as the chosen one. Not with a brother who'd already had a ghost visit, along with his aura-spotting and future-predicting dreams. It is possible my grandfather saw the same psychic potential that runs through the women in my family, even if I didn't sense

or feel it myself. And then something happened. I don't resist this story. I don't try to rationalise it. I try to leave my *matter can neither be created nor destroyed* thoughts aside, and I go with it.

The single bed in my old bedroom in my parents' house runs underneath the window and looks out onto a flat roof. For months after she died, before I'd go to sleep, I dived under the curtains and looked out the window into the night. Watching the stars, I'd talk to her. Possibly – because I still believed in God and heaven and saints back then – I prayed to her. Deified her, implored her as a penitent does a saint. But mostly, I chatted about missing her, about where life was at. A year after she died, I went through a low period. Lying under that dormer window, mind restless, I spiralled in the sheets most nights and spent a lot of time crying in the direction of that wall. So I talked to my grandmother, gazing up at the boxy outline of The Plough, or trying to gauge what kind of moon was up that night. I'd lie down on my side, my survey of the stars complete, and ask her to make everything better. And one night, I felt something. A hand on my shoulder, squeezing reassuringly, and then stroking my back, as you would an ill child.

Turn around. Turn around. Turn around.

In my head, my voice commanded me to do so. My body felt nailed to the bed, but every part of me wanted to rotate. I opened my eyes and the room was all blue light. This dark corner of the house is immune to moonlight, and yet here it was, filled up with a cerulean shade. I did all those movie things, those things my brother did when Annie was

sitting at the end of his bed – pinching, opening eyes wider, talking to myself: *This is real, right? You're not asleep are you?* I was awake, I know I was, but fear trumped curiosity. I was paralysed and listened to my heart banging in my chest. To this day I regret not turning towards the blueness to find out what was there. If my grandmother was standing beside my bed, I should have had the manners to acknowledge her. To ask how she was and if she missed her life.

Mostly though, I should have remembered her words.

You should be more afraid of the living than the dead.

No matter how much I have loved someone in life, or how deep my grief – when they die and are buried, I will not visit their grave. Graveyards are shrines for some, but I feel nothing there. A box in the ground buried under damp soil bears no resemblance to the person I once loved. *When I die cremate me*, I say. *Remove my rings (good luck prising all the metal from my body) and torch my remains like a pyre.* Grass now grows over my grandmother and I think of her pulling up those yellow weeds from the lawn, not knowing that the end of her life was moments away. Of taking her last breath standing on the grass, like the green hull of her final resting place.

Before finding themselves beneath a neat, verdant rect-angle, everyone should leave the place they're from, even if just for a short while. When I think of my grandmother, I feel the small circles of her world; her linear life and its minute map, her huge losses and sleepless nights. It's not

that I wish her a bigger life, filled with broader horizons, but that there was more peace within it, a measure of ease.

The American writer Barry Hannah said that there's a ghost in every story: a place, a memory, a feeling long forgotten. Experiences that never fully recede, people who leave an imprint. A permanent, if invisible residue. Memories sooted and flower-pressed; a part of us now, like a prosthetic formed of the past. For a long time, my grandmother was a ghost in her own story, living outside of herself as a result of fear and grief. Her mother was haunted too, and if there is an afterlife, or some residual space, a place where the ghosts of the men who came to them are, there is a chance that they are all together now. Alongside the women who preceded them, those armies of mothers and Magdalenes, women who wanted so much from the world; women who never asked for anything; women who walked those hills, calling into the wind; disappeared women, ground down by fate; but women, too, who left for something better, or those who found a sense of self – either peace or wildness within; women who found whatever it was they wanted; and all the women who walked into the fire of the future without a backward glance.

Where Does It Hurt?
Twenty stories based on the McGill pain index

The McGill Pain Index was developed in 1971 as a method for assessing pain according to a scale. Doctors devised 77 words for pain, which are divided into 20 groups, and patients select a single word from each group. They then choose three words from groups 1–10, two words from groups 11–15, one word from group 16, and one word from groups 17–20. The patient then has a selection of seven words that describes their sensation of pain. But words are often insufficient where pain is concerned. The patient is free to select multiple words, but pain cannot be reduced to one lexical bracket. It is difficult to explain a specific pain to someone who has never experienced it, or to someone whose life has been largely devoid of pain. Medical practitioners created the list and chose the descriptors. The words do not come from the person experiencing the pain; the words belong to the doctor, not the sufferer. This is an attempt at reclamation.

How many times have you been in pain? Did you have all the words you needed to tell the story of it?

What is the vocabulary of pain?

Flickering, Pulsing, Quivering, Throbbing, Beating, Pounding

Washerwoman's Sprain

In his cot, my son, so longed for
Is a white seal cub,
Soft with no edges,
Eyes a religious blue,
Will they stay that shade?

His clam knuckle
Skin shell grooves

I pick him up, this almost person
Notice a new pain
In the wrist I don't write with
The source is tendon
Not bone.

Soon I cannot lift him
Or coax the milk bubbles
From his belly
By flattening my hand
On his spine

De Quervain's Disease
Says the specialist.

Or *Washerwoman's Sprain*
(Not *Washerman's*).
A reminder that
It is women
Who wash, carry, feed,
Women whose bodies
are the casualties of birth.

Jumping, Flashing, Shooting

Post-Surgery Drain Removal

A clear tube enters my body, a medical snake.
No venom or bite. The removal of old blood, bone
 crumbs, surgical detritus.
The drain-circle fills up, a white plastic sun.
I ask them to tell me when, as if starting a race.
Ready – Steady – Go!
To count me in, as though it is my turn to sing at the party.
Wine drunk, the hour late.
Count me in and I'll open my throat.
1 – 2 – 3!
Tell me when you're going to do it.
I will
Tell me when
OK
Tell me—

Pain forks in flesh, the tube yanked from deep inside.
 It emerges, a doppelganger birth with fake umbilical
 cord. The remaining hole, a red coin on skin.

Pricking, Boring, Drilling, Stabbing

Lumbar Puncture

Divining with needle, not rod
For cerebrospinal fluid
Drilling into vertebrae
Corkscrewed
Which grape am I?
Foetal-bent, focus on the highest
Point in the room, because pain
Is altitude; mountain sickness.
Newly mined, I can't walk for two days
What food am I best served with?

Sharp, Cutting, Lacerating

Impacted Wisdom Tooth

I talk a lot
but never knew
my mouth was too small
until an oral surgeon says so.

156 — Sinéad Gleeson

These words make me giggle.
Childish, I know.
A troublesome tooth
breaks the skin
Sideways, not upwards.
A drunk leaning on a bar.
Growing into another molar.

The skin tears,
a spring plant
breaking through soil.

The surgeon declares me
The owner of
A small bite radius.
This will amuse my friends
Because word always gush from me.
A geyser of sentences
But now I have medical proof
Of a minute mouth.

Under anaesthetic,
Metal twists
in the tiny cave
of my mouth.
Molten gums.
Waking numb,
The brick removed from the wall of my teeth.

Over dinner, I tell friends the bite radius story.
We compare, and take photos.
My gay friend with the beautiful, full lips says a small
 mouth would be a problem for him.

We laugh.
Wine puckers in the empty bed
of that now-departed tooth.

Pinching, Pressing, Gnawing, Cramping, Crushing

Unexplained Headaches

They recur these infections,
returning like sailors with the dawn,
from things they wish they'd never seen.
There is a mouse in my skull,
Skittering within my cerebrum,
gnawing at cells.
Where balance and posture are controlled.
Is it head or brain or tooth or jaw?
I am a bad archaeologist,
Like the ones in Indiana Jones
digging in the wrong place.

Down that ear canal, pain spirals
Once, I had vertigo, and clung to a wall

As though on a sinking ship.
I swim between the hammer, anvil, stirrup
Ossicles oscillating.

In the MRI tunnel, music plays: The Carpenters'
 'Superstar'.
I focus on Karen above the noise of the machine.
Which parts of my brain light up thinking of love? Or
 fear? Or Karen Carpenter?

This is not a coffin. This is not a coffin. This is not a coffin.

The mantra doesn't drown out the pneumatic pulse. *Are
 you there, Karen?*

Tugging, Pulling, Wrenching

Smear Tests

If someone said they'd put the moon
Inside you, there is a chance
You would consent
To feel the white cold of it

Soles together in
Reclining Goddess Pose
Feeling less like a deity
Than a speculum's captive

Hot, Burning, Scalding, Searing

Heartburn (in pregnancy)

It arrives like a stranger in town, an unfamiliar car cruising
the street as mothers watch through curtains.

This experience is commonplace for many, but new to me.

On TV, there are ads for gloopy pink medicines. Actors
clutch throats, frowning, performing discomfort.

My father's stomach is complex; in synchronicity with
my life. When my mother was pregnant with my brother,
his ulcer perforated. He worked near a hospital; the
proximity meant he didn't die.

But it left a phantom in his gut that has haunted his life.

Heat rises up. Alimentary canal as fire hazard, not
phoenix.

Words challenge the inferno, but turn to ash in my
throat.

Wanted: one hydrant, hose me down.

Jaws chew chalky tablets and

It is quenched, as if

I'd fought it with a river.

When I am not pregnant I resolve to eat jalapeños
straight from the jar.

Tingling, Itchy, Smarting, Stinging

Eye Injury (at a music festival)

People on every inch of grass
Music bleeds from one striped marquee to another
We dance like pagans, into the night, in the rural pitch dark,
The campsite generators hum as we pick our way
through tents strewn like battlefield bodies.

Then one eye doesn't open.
Spilling fake tears.
A golf cart arrives, a makeshift ambulance,
Driving comically up grass aisles,
Bouncing over beer cans and
the outline of fairy forts
I make a pirate patch
With the back of my hand.

In a medical tent, a doctor – too handsome – tilts my head
gently. At each forty-five-degree angle, he asks personal
questions.
 Are you here with a partner?
 My husband.
 Has anyone hurt you?
 No!
 He makes me wonder if this is common. If guys hit
their girlfriends under coloured flags, after marrying in an

inflatable church. Amid all that life, is there still a knuckle
to the face?

He says, *a foreign body.*

I think, *too much dancing, no sleep.*

Dull, Sore, Hurting, Aching, Heavy

Not Breast-Feeding

Heparin
Cabbage leaves
The sadness
The judgement

Tender, Taut (tight), Rasping, Splitting

Scars

Sometimes they have teeth,
a mouth sewn up with metal
As though protesting.
Skin clamped,
To induce healing.
Or they are paper,
For shallow wounds.
Medical thread, thick as eyebrow hair –

Platelets march over the hill to the battle trenches of the
 body,
An army of coagulation captains.
Working quickly, until softness becomes a seam,
a boundary wall on the body.
It itches, *yeah, like you wouldn't believe.*

You watch its progress, its possibility.
Don't cough, it'll split,
It pulls itself together,
A gathered bow, pursed lips.
A new pin dropped on your map.

Tiring, Exhausting

Pregnancy

Hunger is a steam train,
I shovel food
To drive nausea away.
Throat burns, hotter than coals.
Past stations named for weeks and trimesters
This baby and I,
Two tracks running into the night.

Sickening, Suffocating

Lung Clot

No breath is deep enough
to fill the well of my lungs.
Inhale fully, as if smelling
Petrichor, bergamot, a baby's skin.

On the X-ray, the doctor points at the mass
Circling it with a pen.
Is that from years of social smoking?
No – that's your clot.

Breathe as if air is running out,
in a container or a coffin.
Each intake is a knife in the chest
Rationed until they are less frequent,
shallow and incomplete.
Lungs collapse, fungal pneumonia
To stop pain, and reinflate,
A morphine pump feeds into your stomach
And for a day it's magic and lightning

My father says I solved
The meaning of life
What did I say? You bend your ear.
Christ! I couldn't follow you, love.

You:

– think people are there who aren't.

– cry apocalyptically.

– have nightmares full of blood and animals.

– scoop up handfuls of bathwater and throw them at your
husband, as if putting out a fire.

But it works, this poison.
Lungs recover, you suck in air,
deep as a joint.

Fearful, Frightful, Terrifying

A Fall

In front of an audience, I interview a feminist academic.
She is smart and funny. We unite in our horror of
patriarchy, exchange stories of harassment the time we
shaved our heads.

*Men always make assumptions about sexuality, availability
and attitude based on a woman's hair*, she says.

Afterwards, under the warm June sky, I miss my footing
on a slanted street. Turn and turn, a dervish girl, fear rising
up before I hit the ground.

Slap of concrete. Hip takes the brunt, except it's not bone,
but ceramic and titanium. The stars scold my clumsiness.

In the ambulance, I do that thing that women do –
even in fear – I apologise. For taking up their time, this

stretcher, one side of this vehicle with tubes and masks.

I know many kinds of soreness, but not this.

In the X-ray department, staff surround me.

On my count, lift! and from head to toe, my body detonates.

A kind of hurt that is atomic, radiating mushroom clouds.

Fear of what I've done.

The ceramic ball of your hip replacement may have exploded.

I did this to myself.

A physiotherapist identifies the problem: severe bone bruising.

As painful as a break, regularly seen in skiing accidents (I have never been skiing). In the heat of the ward, I long for snow, a blizzard, an avalanche.

You dodged a bullet, says my orthopaedic surgeon a week later.

Punishing, Gruelling, Cruel, Vicious, Killing

Unlistened to Pain

I have been condescended to by enough consultants to know when I'm not believed. When I try to use words like the ones on this list, to articulate and communicate physical distress, sometimes I cannot find the word, or know there may not be one. Patients fight for their health to be acknowledged, to be treated, for someone to say:

I know what this is, and I will help you.

Pain is about answering a question the body asks. It is shared to find a solution, but is often met with doubt.

Is it really that bad?

Illness of any kind requires a private designation. It has become acceptable that many conditions are played out in waiting rooms, wards and surgeries. Rendered public, making the experience of illness political – to borrow Hannah Arendt's assertion that any act undertaken in public is a political one. Women learn early that absorbing pain is a means of martyrdom inching us closer to the bodies of saints, as if discomfort equates to religious ecstasy. That there is meaning in suffering, except that there is not.

Wretched, Blinding

ATRA Side Effects

Capsules of red and yellow
A kind of semaphore
Pool table balls
Dose: nine a day
(four in the morning,
five in the evening)
for fifteen days.
A split ritual:
is the morning yellow
and the evening red?

ATRA. All-Trans Retinoic Acid
Contains arsenic, but
A good kind of toxic.
Not botulinum, polonium.

Side effects:
Headaches worse than hangovers.
Skin dry, desiccated.
Blurred vision, eyes on strike.
Shapes on my retina,
A rotating swastika.
A fertility symbol
Until Nazis stole it.
I find other words:
Tetraskelion.
Fylfot.
Gammadion Cross.

Annoying, Troublesome, Miserable, Intense, Unbearable

Knocked Down by a Car (Hip)

Against a tall concrete wall, a line of children's arms form a bridge of flesh. I dip under, run the length of them, and they are free.

This time, I am the hero of the game, emerging from
beneath the last arm. Triumphant, ready for a victory
strut, darting between two parked cars out onto the road.

A maroon mirage, and the bumper hits.
Throws me to the ground.
My softness incongruous
against the road.

Get up, get up

The driver's frightened face is freeze-framed panic.
Someone scoops me up, runs to my parents'
Children streak behind, Pied Piper-esque,
I'm carried from kitchen to hall.
Trying to locate my mother's shouts
We miss each other in every room.

The local doctor is terse.
Nothing broken, you're fine.
This is where it starts.
The first medical diss and
Dismissal.

It hurts for days, deep down,
But no permanent cuts or scars.
A get-well gift of a jungle jigsaw.
I work on its edges, watch bruises appear
like lily-pads on skin.

For decades doctors try to solve the riddle of my bones
and ask:
Did you ever fall, or have an accident?
I nod, but it's not the answer to their question.

Spreading, Radiating, Penetrating, Piercing

Breast Cysts

Of all the words for pain, here are the truest:
Spreading, Radiating, Penetrating, Piercing
A scald, or St Sebastian's arrowed flesh.

In the breast clinic, women with pale faces watch
the rolling news. Blue-gowned handmaids. Mastectomy
matriarchs. Waiting for names to be called in the hand-
sanitised air.
Granular is a new word. Of cereals, grains of sand, salt
marshes, mountain grit.
Moon dust and space rock, asteroid belts under the flesh.
The sharpness is a surprise. I expect soft dullness
among all the flesh of my breasts.
An ultrasound shows charcoal circles, non-planets.

Please don't be cancer.

A needle pushes in, the sting of penetration
Dark orbs liquefy, a fetid flood

filling the syringe.
Lumps still lurk,
but I know
Each crater and black hole,
Every inch of the body's solar system.

Tight, Numb, Squeezing, Drawing, Tearing

Side Stitch

Nostalgic for the stab
In the side
From running too fast
Aged eight, or maybe ten, hazy.
Over hedge hurdles, long grass
A triumphant soundtrack in ears.
The burn meant you were the winner.
In a race as distant as mittens and milk teeth.

Cool, Cold, Freezing

Nerve Damage

There are parts of my skin
That never heat up,
As though shaded by trees
On hot days.

Nerves tingle and underperform.
A stray scalpel
Offers a bladed kiss.

Nagging, Nauseating, Agonizing, Dreadful, Torturing

Labour

A planned date for both births,
No wait-and-see
Nor spontaneity.

Or so I thought.

Both early,
Contractions rolled in,
Depositing aches like driftwood
My son lay on my spine,
Or maybe hiding behind it.
My daughter's contractions
started weeks too soon.
Tumble-tugged. Oblivion.
As bad as they all said.
Iced spinal block
as entrée.
My belly cut open
As if for a feast.

172 — Sinéad Gleeson

My obstetrician drove
250 kilometres
to welcome you.

Your babies are always in a rush, she says.

A Wound Gives Off Its Own Light

A wound gives off its own light
surgeons say.
If all the lamps in this house were turned out
you could dress this wound
by what shines from it.
Anne Carson, from *The Beauty of the Husband*

Illness is an outpost: lunar, Arctic, difficult to reach. The location of an unrelatable experience never fully understood by those lucky enough to avoid it. My teenage years were filled with hospitals and appointments, calendars circled with dates for surgery. The arrival of unfamiliar objects under skin. This malfunctioning version of me was a new treasonous place. I did not know it; I did not speak its language. The sick body has its own narrative impulse. A scar is an opening, an invitation to ask: 'what happened?' So we tell its story. Or try to. Not with an everyday voice, no, that doesn't suffice. To escape illness or physical trauma, some turn to other forms of expression. It can feel necessary. Illness tries to diminish the sufferer, but we resist it by containing its expansion. The patient's attempt to understand

their predicament is akin to applying a tourniquet. Art, for some, becomes a source of distraction, a welcome focus to blot out the boredom that comes with this new patient life. I gravitated towards writers and painters. People who told the stories of their illness; who transformed their damaged bodies into art.

At the age of eighteen, a bus accident changed Frida Kahlo's life forever. Later, she said of it, 'The handrail pierced me as the sword pierces the bull.' The explosion blew her clothes off, and another passenger, possibly a decorator, had a bag of gold powder among his painting tools. It burst on impact, showering an already naked and bleeding Kahlo. Her boyfriend recalls that when people saw her, they cried, 'La bailarina, la bailarina!' Gold mixed with red on her bloodied body, and they thought she was a dancer, limbs decoratively twisted among the wreckage. Surgeons who initially treated Kahlo didn't think she would survive her injuries – a fractured pelvis and collarbone, broken ribs, a broken leg and a mangled foot. Her spinal column shattered in three places, a triptych of bone.

Over the course of her life, Kahlo had more than thirty operations, including the amputation of her leg at the knee. Grappling with childhood polio had been bad enough, but the accident and its effects were catastrophic, and her pain was chronic. Kahlo married Diego Rivera in 1929, when she was twenty-two and he was forty-two. Their connection was founded on art and politics, volatility and attraction. For all

his support of her work, and the omphalic nature of their bond, Rivera could not put himself in Frida's place; her suffering was hers alone. Pain – unlike passion – has no commonality with another being, it has no shareable fragments.

I found Frida during my teen hospital years. Our health issues differed vastly; hers were debilitating in a way that horrified me. I didn't dare equate her suffering with mine, but our experience felt kindred. Then, and even now, my body is rarely without it. A life with pain is a distracted one, where every thought is always second to the source of where it hurts. Pain is a reminder of existence, bordering on the Cartesian. *Sentio ergo sum*: I feel, therefore I am. Some translations suggest *patior ergo sum*: I hurt/suffer, therefore I am. Yet, the physical experience resists words, refuses to reside within letters. They fall short. Woolf, in 'On Being Ill', writes:

> Finally, among the drawbacks of illness as matter for literature there is the poverty of the language [. . .] let a sufferer try to describe a pain in his head to a doctor and language at once runs dry. There is nothing ready made for him. He is forced to coin words himself, and, taking his pain in one hand, and a lump of pure sound in the other [. . .] so to crush them together that a brand new word in the end drops out.

My admiration of Kahlo has always been about the work; the transference of her life onto canvas, the self-reflection, the engagement with the taboos of illness and the female

body. In 2005, I went to see a major retrospective of her paintings at the Tate Modern. To wander from room to room was to be confronted with several versions of Frida. The multiplicities of her: as artist, as woman, as patient. On every wall was a different her. I stood rooted to the spot in front of her painting *The Broken Column*. In it, a huge opening runs through Kahlo's torso, revealing her ruptured spine. Instead of bone, it is depicted as an Ionic column, an indication of Kahlo's stoicism, refusing to give in to suffering. Hundreds of nails are embedded all over her and tears run down her face. The painting is not just a representation of pain, it physically epitomises it. Whenever I see it I almost wince, complicit in the sensation it evokes. Kahlo longed to have a child with Rivera but her body, damaged by the bus accident, was unable to carry a baby to term. Her first and third pregnancies ended by surgical abortion because of the risk to her health, and her second pregnancy in 1932 ended in miscarriage. Kahlo's compromised body conspired against her, denying her not just health but the chance of motherhood. *Henry Ford Hospital*, *Frida and the Miscarriage* and *Frida and the Caesarean* (unfinished) were all painted in 1932. Art and motherhood became mutually exclusive, but motherhood – spectral and unrealised – recurs on the canvas. In the history of her body, the maternal lurks just outside the frame.

The twisted bones, the diminished sense of self: I connected with Kahlo. Every night before surgery, after every post-anaesthetised fug, every needle, cut, puncture wound, I thought of her. The sense of a body that refuses to keep up

its end of the bargain. In 2018 I saw another Frida exhibition, but this one – at the V&A – focused on objects from her life. There were nail varnish bottles and face creams; clothes and books. But I was really there to see the detritus of her medical life. The exhibition was lowly lit, the rooms small and busy. Rounding a corner, I suddenly found myself looking into a glass case of her plaster casts and surgical corsets. Unexpectedly, I felt tearful. This was the reality of Kahlo's life, the objects that both helped and constrained her. Essential, but also the source and symbol of her suffering. My mind pulled up the image of my own plaster cast, from years before; of feeling miserable and immobile, wondering how permanent the effects would be.

In many of her self-portraits, Frida is pictured as pierced, penetrated or slashed. They are unflinching images, often paired with zoomorphic versions of herself. In *The Wounded Deer* (1946), she depicts herself as an animal shot with arrows. In the bottom left corner of the painting, the word 'karma' is visible. The appearance of the word initially baffled me. It seems inconceivable that Frida thought she deserved her pain, or that she felt she was being punished. But perhaps my assumption is based on thinking of karma as a cause-and-effect concept, of reckoning and rebirth, when it can also allude to action and work. That Kahlo chose to make an active life of art out of the confines of her predicament. I think of the word – one of the few words that appear in Kahlo's paintings – as a testimonial. An acceptance of what she cannot change. If you are fortunate, illness is a car that leaves the road and ploughs harmlessly into a ditch.

You throw open the door, dazed, and walk away. If luck deserts you, the car dives over the cliff into a ravine below. An orange explosion of fuel and contorted metal.

After the bus crash, in 1925 doctors placed Kahlo in a full body cast to help her bones heal. It fulfilled its medical purpose but was, to Frida, a prison. Bored and confined, she began to paint. Unable to sit, her mother bought her a special easel, and later, a mirror was positioned above her bed so that she could paint herself. A medical cast is one way of obscuring the body. Kahlo tried to capture the self that was hidden beneath. For the months I was sealed into my hip spica plaster I thought of it as a tomb, but Frida saw the possibility in her cast. All that was done to Kahlo's body is revealed in her work. She decorated the plaster and painted an ornate dragon on her red, prosthetic leg, which was the closest she ever came to using her physical self as a canvas.

The word 'stillness' also contains 'illness'. My bedbound years formed in me a constant reader. Books made being indoors and unable to move more bearable. In the months after her accident, Kahlo took refuge in painting – but what if there had been no collision? If Frida had been somewhere else on the day of the crash, would she still have become a painter? Her plan, before discovering art, was to become a doctor. Immobility is gasoline for the imagination: in convalescence, the mind craves open spaces, dark alleys, moon landings. Her paintings are a lesson in corporeal

panic, body-in-peril, a way of communicating pain to those unversed in it. Illness and art may be subjective, but when I first encountered Kahlo's paintings, they represented exactly what I felt, in a way my teenage self could not describe.

In all her years of painting the problem of her body, her brokenness, her infertility, Kahlo never painted in detail the scene of the accident. Never the carnage, the ripping apart of bus and bones. She only drew the aftermath once, in one rough lithographic sketch called *The Accident*. Rivera and Kahlo collected Mexican ex-votos – small paintings offered to saints as thanks for surviving illness, injury or death. Frida painted over one that contained a bus crash scene, altering the destination to 'Coyoacán', and the face of the prone victim to her own, unibrow included.

In her painting *The Bus* (1929), she depicts herself alongside her fellow passengers just before the accident. It captures the moment before her life changed forever, the moment before her near-death, the last moments of her life that would be pain-free. When I look at her work, I am struck by the way the language of the body, with all its heat and movement, is at odds with the medical words of science. For Frida, no words were enough. They were too slight or generic. In illness, it is hard to find the right words. Jo Shapcott's 2010 poetry collection *Of Mutability* was written after a diagnosis of breast cancer. The word 'cancer' never appears once in its pages, and the book is dedicated to Shapcott's medical team. Words can fail us, and they failed Frida. They could not harness what she wanted to say. For her, art – not language – was the medium of her agony.

When Lucy Grealy's health began to dominate her life, she immersed herself in language – poems, essays – to express her situation. Born in Ireland in 1963, she relocated to the US with her family soon after. At the age of nine, she was diagnosed with Ewing's sarcoma, a rare facial cancer that required the removal of most of her jaw and three years of chemotherapy and radiation. By the time Grealy was in her mid-twenties – and on her way to becoming a feted writer – she'd had close to thirty operations (the same number as Kahlo). Ongoing surgery was a battle, a fight with her own face. The regularity with which doctors opened her up with scalpels, removed bone and grafted skin, took its toll. It was highly invasive, and – because the site of the disease was her face – there was no question of privacy. There was no way to hide this part of herself from the world, unlike a spine or a leg. Her face, sutured and scarred, was on constant display. Illness was a burden, her deformity inescapable, but this was not the worst aspect of her experience. In one frank interview Grealy admitted: 'It was the pain from that, from feeling ugly, that I always viewed as the great tragedy in my life. The fact that I had cancer seemed minor in comparison.'

The confidence in her writing contrasted with the insecurity prompted by her post-surgical face. *Autobiography of a Face* was also the only book that spoke directly, intently, deeply to me about the self-consciousness that physical illness brings, especially at a young age. Grealy evokes the physicality of scars, of imperfection, but she also captures

the loneliness – the aloneness – of illness. She recalls that no one – doctors, teachers, her family – ever asked about what she was going through, or how she felt.

In her writing, Grealy examined her surgeries from every angle. Medical intervention and the prepping of a body to be cut open involves contact and tactility; interaction with doctors, nurses, porters: it is a transaction, an exchange. Intrusive to many patients, but to Grealy a form of connection, an acceptance of help and a means of gaining attention. 'It wasn't without a certain amount of shame that I took this kind of emotional comfort from surgery: after all, it was a bad thing to have an operation, wasn't it? Was there something wrong with me that I should find such comfort in being taken care of so?'

Perhaps writing offers more cover than art – there are thousands of words to hide behind. In writing, unlike painting, and specifically Kahlo's work, the writer does not explicitly put the body on display. Words are fig leaves, a modesty patch on the nakedness of the ill body. Frida worked primarily in oil and seemingly left no part of her physical self unexplored on canvas. Is paint or sculpture more distancing than having to take a photo of ourselves? The form of the modern self-portrait has evolved, the months of labour in an oil painting now expedited in a selfie. Would Kahlo have rejected the instant nature of such images? The idea that a photo, taken in one second, cannot represent months of pain. That layers of oil and reworked brush strokes hold something more of the experience. But Kahlo also hid her body using colourful clothes, many from

the matriarchal Tehuantepec region of Mexico. In the 1934 charcoal drawing *Appearances can be Deceiving*, she depicts a see-through self, her injuries visible beneath her dress. 'I must have full skirts and long,' she remarked, 'now that my sick leg is so ugly.' I think of the long list of clothes I avoided when younger. Anything tight or short; fabric that clung to the body, accentuating my lopsided walk, the loathed limp. Unavoidably, my leg has shortened more with age. I've been advised to add shoe lifts to my wardrobe to combat the disparity in length, to offset the daily pain in my spine. Sometimes everyone hides, perhaps protective of the self we offer to the word; resisting the props that become necessary to living. In the end, we all take cover.

In using her body as subject, photographer Jo Spence (1934–92) was absolute. The decision to point the lens at herself was directly linked to her health. After a diagnosis of breast cancer, Spence made it the subject, the very centre of her work, documenting parts of her body, pre- and post-surgery. In the collaborative series with artist Terry Dennett, *The Picture of Health?* (1982–6), there is a particular image that makes my heart race, even now. The photo is taken on a hospital ward, at a slight remove. It is a patient's-eye view, possibly Spence's, from a couple of beds away. The camera is trained on a group of doctors crowding around the bed of a patient. In medical attire, uniformly white, they are indistinguishable from each other. The viewer sees only a throng, not the individuals that comprise it. There may

be safety in numbers, but in a hospital scenario, it has the opposite effect. The result evokes a sense of threat. In such a confined space having strangers flank a bed is oppressive. There is no privacy, rarely greetings. Those who talk are brusque; those who don't simply stare. Impassive, committed to the medical narrative being explained to them. 'The patient has X and presented with Y and is being treated with Z.' These team visits used to frighten me so much. I felt scrutinised and voiceless, a specimen in a jar. I was present, but not invited to be part of the discussion. In Spence's photo, the entire group is male.

In *Cancer Shock*, Spence wrote of one such encounter with a doctor:

> One morning, whilst reading, I was confronted by the awesome reality of a young white-coated doctor, with student retinue, standing by my bedside. As he referred to his notes, without introduction, he bent over me and began to ink a cross onto the area of flesh above my left breast. As he did, a whole series of chaotic images flashed through my head. Rather like drowning. I heard this doctor, whom I had never met before, this potential mugger, tell me that my left breast would have to be removed. Equally I heard myself answer, 'No'. Incredulously; rebelliously; suddenly; angrily; attackingly; pathetically; alone; in total ignorance.

Spence is mostly known for her photography, but also used words, chopping up newspaper cuttings to create mon-

tages. *Cancer Shock* is a photo-novel that includes images of her medication and surgical wounds. She both resisted and assimilated medical representations of the self in her work. 'I want,' she said of *Cancer Shock*, 'a record of my mutilated body in sharp, stark, medical style.' Spence was vehement: telling her audience – and doctors – that even if operations and dissections were necessary, her body belonged to her. The images are an attempt to retain control and assert agency. I related to her mission, when I first encountered her work in 2012, as part of a group exhibition in Ireland entitled 'Living/Loss: The Experience of Illness in Art'. I wrote a piece about the show, and my own life seeped into it. I realise now that it was the beginning of self-investigation into my own illness, largely prompted by Spence's images. *The Picture of Health?* includes one of her most famous photographs. Taken the night before a lumpectomy, she stands naked from the waist up, expressionless, but staring directly into the camera. On her left breast are the words – and an insistent, utterly necessary punctuation mark – *Property of Jo Spence?* It is unwavering, slightly menacing, but full of dignity.

Acts of resistance came naturally to Spence, who never called herself an artist, preferring her own definition of 'cultural sniper'. A blurring of lines between public and private, subject and object. Like Cindy Sherman's, her work is photographic autobiography, but where Sherman dresses up and recreates exaggerated versions of womanhood, Spence uncovered herself, paring back to an unadorned real woman dealing with disease. Her work is anti-camouflage, anti-victimhood. Being a statistic within the public health

system objectified and dehumanised her, and inspired her to push back. 'Eventually I began to see the body as a battle-field,' she wrote.

It is difficult for a female artist within patriarchal culture not to be subsumed by it: fetishised, feminised, sexualised. Kahlo was recently immortalised as a Barbie doll: her skin lightened, her body made symmetrical, her disability – and ethnicity – airbrushed. Ahead of the V&A exhibition, one female journalist wrote of her: 'Her self-portraits are dec-orative, but never fussy. Like any great brand, she has an image that is almost childlike in its simplicity,' comparing her famous eyebrows to the Nike swoosh. This co-opting of Kahlo wilfully misses the fundamentally radical representa-tion of herself and her identity in her work.

A significant motivation for many artists, and particu-larly Spence, is visibility. If people do not see themselves represented in a culture, there is an urgency and need to create that space. As a woman, and an ageing, sick, working-class woman, Spence craved that representation. A version of art for her, and women like her. With Rosy Martin, Spence worked on a series called *Phototherapy*, combining both comic and feminist ideas, and an opportunity for healing from physical affliction or past traumas. The work is provocative, but includes some of the most playful images Spence ever created – as housewife sucking a baby soother, and as Rosie the Riveter about to smoke a cigarette. In dealing with the most serious of subjects – mortality, trauma – Spence some-times chose humour.

Just as I think of Kahlo before each of my surgeries, Spence's photos rise up in my mind: the circled pack of doctors, the writing on flesh. Back on a busy ward, pre-meds taken, the familiar gown on, a nurse arrives to draw in marker (black ink, or blue?) on my skin. An 'L' in a circle to identify the correct leg. Temporary marks ahead of stitches that will one day fade but never disappear. I think of this act as a kind of artistic process: art as instruction and direction. Last year, ahead of a mammogram, ultrasound and needle aspiration, a doctor drew circles around the cysts in my breasts. On the screen they looked like hailstones, or comets.

In exploring Lucy Grealy's writing, there is a sense of embracing excess, of never holding back or turning away from the unconfrontable. In Kahlo, there is stillness, and stiff, upright poses, but in Spence there is energy and movement. In *I Framed My Breast for Posterity* Spence is at home – not in hospital – surrounded by familiar objects, instantly reminding us of the illness forcing its way into her daily life. She is at the centre of the image, and to her left is a photo of a group of workers, all men. She is naked from the waist up, except for a pair of beads, and a bandage loops under her left breast like a sling. The wooden frame is deliberate, held over her breast, making it the focus of the entire scene. Spence is telling us – *showing us* – that her physical self is not an ephemeral collection of skin and cells, but through her art, is an immortal work that will endure. Through those years of hip surgery, I chose to hide

my body a lot, but Spence confidently exposed hers, making it into its own declaration.

Kahlo died in 1954 aged forty-seven, a year after her leg was finally amputated; Spence in 1992 from leukaemia (was it the same kind as mine?), and Grealy, who became reliant on painkillers, a decade later at thirty-nine from a heroin overdose. Representing a diagnosis – in art, words or photos – is an attempt to explain to ourselves what has happened, to deconstruct the world and rebuild it in our own way. Perhaps articulating a life-changing illness is part of recovery. But so is finding the kind of articulation that is specific to you. Kahlo, Grealy and Spence were lights in the dark for me, a form of guidance. A triangular constellation. To me, they showed that it was possible to live a parallel creative life, one that overshadows the patient life, nudging it off centre stage. That it was possible to have an illness but not to *be* the illness. They linked the private (isolated) world of the sick to the public one of creative possibility. That line from Carson – 'a wound gives off its own light' – exemplifies what these three artists did. That in taking all the pieces of the self, fractured by surgery, there is rearrangement: making wounds the source of inspiration, not the end of it.

The Adventure Narrative

'There is no doubt that running away on a fresh,
blue morning can be exhilarating.'
Jean Rhys, 'The Left Bank' (1927)

The road sign at the mouth of the cul-de-sac is wooden and hammered into the grass, chest high for a child. We flip over it, imagining it is a gymnast's asymmetric bar. For an electrifying moment, the world is inverted, green where blue should be. The sign sits at the top of a small hill, which we roll down, radial spokes in a wheel, laughing our shrieks. Grass clings to elbows and the sky divides itself: one shade at the top of the hill, a different one by the time we reach the bottom.

It must be summer because the evenings are bright, the sun still high in the sky. The moon is also up; chalky, a shadow of its night self. Something about it, or the hue of the sky, or the lone cloud, speaks to me of how big the planet is. This small estate is not wide, nor is this suburb named for a plague grave, nor even this city. *The world is out there*, it says.

Close your eyes.
Think of an adventure.
What do you see?

Perhaps one of the following:

A) Rigging rattles, sails flap. Deck scrubbed and tarred, groaning with the weight of cargo. Foot leaves land, climbs gangway. Anchor up, push off, deep furrows of ocean, thousands of miles. It begins.

B) High up on the slope of a mountain, above basecamp where blood thickens. Cloudless, the glare makes it impossible to see. Taut ropes, bodies as anchors. Ascent.

C) Snow packed tight, an unchanging landscape. Tents, food, maps piled high on sleds. The only sound: wind and the crunch of boots on ice. Someone dies from paradoxical undressing, where the brain, fevered and convinced the body is overheating, causes a person to remove their clothes, as though peeling off for a swim. Hypothermia moves in quickly. Fingers snap off like twigs.

These kinds of stories persist. Timeless accounts of valour and daring. Adventure tales that have been told on repeat, each time re-stitched with a new fact or untruth. Adventure is the green weight of the jungle or a ship on high seas, the accumulation of miles, a leaving behind. Every telling is a retelling, transplanting readers, mapping each of us inside

the story. I have imagined myself into these landscapes, stormed into them, set up camp on snow, stowed away – but for centuries, these stories did not belong to women.

Look backwards: a viewfinder of familiar faces clicks past. Magellan and Amundsen, Captain Cook and Francis Drake, 'Dr Livingstone, I presume?' Accounts of derring-do dominated by men. Across the blue of miles, the adventure narrative has always been built on stories of masculinity. Men are its central subject; more worthy of defining it and experiencing it. If there are stars to sleep under, prairies to trek or swells to navigate, history is keen to impart that it falls to an oil-skinned, fur-wearing, grime-faced man. Women stayed home, maintaining the equilibrium of domesticity.

Leaving on a whim to go travelling was traditionally the preserve of one gender, and those of means: money, and being male, helped. The demands of home anchored women there and it was men who got to leave. But not just to leave, or to encounter the possibility of adventure. Leaving was also a licence to drop all responsibility – of making a wage, or helping to raise a family. No wonder it seemed so inviting, this complete divesting of domestic expectation and workaday commitments. The possibility of circumnavigation, one of the greatest possible adventures there is, was a male preserve – at least until Nellie Bly decided otherwise. In 1889, the American newspaper she worked for decided to recreate Phileas Fogg's *Around the World in Eighty Days* trip. Initially, it was offered to a male staff member, but Bly insisted that she would do it solo. Instead of GoPros and GPS, she took off in the clothes she was wearing, with just a

small bag of essentials. Unchaperoned – a rarity for women travelling in the nineteenth century – Bly took ships and trains, completing the trip in seventy-two days, a record she held for a year. She had to navigate more than seas and cities. Fighting to undertake the trip, one that would absent her for weeks, must have been difficult. Was there opposition? Almost certainly, based on safety fears, or maybe just alarm at this lessening of the gap between the sexes; feigned concern about someone – specifically a woman – having the gumption to just up and go. Most nineteenth-century women in pursuit of adventure would have required the permission of a male relative. *How dare she?*

In living memory, there are countless women who strove to see the world on their own terms. The names of the first women to summit Everest, or reach either Pole, are not commonly known (it's as recent as 1975 that Junko Tabei reached the summit of Everest, and 1986 that Ann Bancroft reached the North Pole, without resupply, in a team). But they're not considered *real* firsts or finish line accomplishments, not as significant as the achievements of their male counterparts. Male firsts are indelibly committed to history. They are taught in schools, immortalised in paintings, and become table quiz answers. What women are lost to history in this erasure?

I have lifted my plane from Nairobi airport for perhaps
a thousand flights and I have never felt her wheels

glide from the earth into the air without knowing the uncertainty and the exhilaration of firstborn adventure.

Beryl Markham was born in 1902 in Ashwell, in the East Midlands in England, a tiny landlocked town miles from any water or coastline. Aged four, her family moved to Africa and she quickly lost herself in the heat of Kenya. Restless and thrill-seeking, Markham trained horses but was always happiest in the air. A qualified pilot, she craved the wide orange of African skies, the wind rush, the chance to regard the landscape from above. She clocked up thousands of hours in the air, delivering post and spotting game for safari hunters. For a bet, Markham became the first woman to fly solo across the Atlantic from east to west, and for the twenty-hour flight took just a sandwich and a flask of coffee. The cockpit (its name a reminder of male purchase, the virility of the space) in her plane was cramped and wooden. Off the US coast, the plane's fuel line began to freeze, forcing Markham to crash-land in Nova Scotia. In the Pathé newsreel footage she is shown smiling, in wide trousers, a small plaster covering a cut on her forehead. Markham wrote an extraordinary memoir about the experience, *West with the Night*, which won many admirers, including Hemingway, who remarked:

> She has written so well, and marvelously well, that I was completely ashamed of myself as a writer. I felt that I was simply a carpenter with words, picking up whatever was furnished on the job and nailing them together and sometimes making an okay pig pen.

Lest Hemingway heap too much praise on a fellow writer, he reminds his editor, Maxwell Perkins, that Markham is a woman (in fact, he refers to her as 'a girl'), and that to be *that* good with words, she must be a despicable nightmare.

> But this girl, who is to my knowledge very
> unpleasant and we might even say a high-grade
> bitch, can write rings around all of us who consider
> ourselves as writers [. . .] it really is a bloody
> wonderful book.

The female adventurer was regarded with suspicion, as though her attempts at self-actualization encroached on the pursuits of her male counterparts. A desire to travel may have provoked incomprehension as to why any woman would want to stray far from hearth or stove. Away from domestic drudgery, of making do, of making food stretch for more mouths, of making everyone else happy before herself. Thrill-seeking women were to be feared; spirited women chastised.

Ireland has been adept in judging its young girls for these characteristics. Punishing girls that were deemed too independent; too full of sharp words and big ideas, or just too full of babies. Sequestered in Magdalene laundries, pregnant and unmarried, they were expected to exude gratitude for being 'saved', a performative kind of salvation. It is bad enough and cruel enough and horrifying enough that girls were made to bear the brunt of something that required 50

per cent male involvement. But other girls ended up there too. Girls who were too clever, too sexual, too much. Girls who spoke up, girls who said *no I won't*. Girls who didn't want the lives their mothers or grandmothers had. Girls who were placed in these homes because they *might* get pregnant. Girls who were coquettish or assured or uncontrollable, for whom incarceration was used as a pre-emptive strike. A prison by another name. If you were adventurous, your adventure ended there. In the cumulative haze of decades of uncompromising laws, there were different journeys. From remote farmhouses to nursing homes or to the attics of relatives in the city; journeys to England to start a new life, replacing the old; journeys that until recently meant that twelve women left Ireland daily to access abortion services.

In the twenty-first century – when it's perfectly acceptable to go almost anywhere – a woman bound for the mountains or forests or the open sea will still be asked, so casually:

Aren't you nervous?

From a young age, whenever someone asked, 'What do you want to be when you grow up?' my answer was always the same: a pilot. On a flight across Europe (crutches safely stowed) I was allowed to visit the cockpit; now, post-9/11, a bygone act. The Air Malta pilot 'handed over' the controls in the tiny space. Above the clouds over Europe, it suddenly occurred to me that sitting in a cramped seat for hours would

torment my problematic legs. That years of surgery meant that I was unlikely to pass the medical. But for a few minutes, nosing that fuselage through all that clean azure, soaring over cloud beds, hands on the joystick, made me happy.

Climbing into the air leaves everything behind: countries, boundaries, time zones. Lifting up off the ground is to be somewhere placeless, and for many women, the skies had their own sovereignty. Before Amy Johnson and Amelia Earhart, there was Anglo-Irish Lilian Bland, born in Kent in the UK, in 1878. After her mother's death, she and her father moved back to his family homeplace, Carnmoney in County Antrim, just north of Belfast. Anything you read about Bland focuses on her love of martial arts, of wearing trousers, smoking, and refusing to ride side-saddle on horses. All of this is meant to snidely reinforce the idea of Bland as masculine, as not like other women. She worked as a photo-journalist and photographer, but had an early interest in flight. The Wright brothers had already made aviation history in 1903, and after some research, Bland built her own glider, and later began work on a more advanced model, determined to eventually add an engine to it. She used spruce and ash for the plane's structure, ash for the wings, and stored the fuel tank in the chassis. The wingspan was just over twenty feet, and the controls were fashioned from the handlebars of a bike. Up on Carnmoney Hill, Bland conducted trials and had a local boy and five members of the RIC (Royal Irish Constabulary) hold the plane until the

wind caught it. She calculated that based on their collective weight, the craft could hold an engine, and bought a twenty horsepower two-stroke engine. After a delay in delivery, and in impatience, she went to Manchester and brought it back to Ireland herself on the ferry. In August 1910, seven years after Orville Wright, Lilian Bland finally took flight. The *Mayfly* reached a height of thirty feet and stayed airborne for just under half a kilometre. Later, in an exuberant letter published in *Flight* magazine, Bland wrote: 'I have flown!' and in doing so, became the first Irish woman to design, build and fly her own aircraft. Her father pleaded with her not to fly, promising to gift her a car instead if she would stop, but Bland had already achieved what she set out to do. Adventure history is full of names like hers – Limerick's Lady Mary Heath, mountaineer Annie Smith Peck, explorer Fanny Bullock Workman – women full of curiosity and allergic to compromise. Bland, Markham and Bly told stories, but also took charge and wrote their own narratives. They ignored the prevailing admonition to stay put and stay quiet. But for every Amelia Earhart or Jeanne Baré or Isabella Bird, there are millions of women not afforded a modicum of miles. No grand adventures or aerial views. Poor girls, women with illness or reduced ability, those whose role in the world has been long decided, immovable as stone.

Wanderlust – with all its romantic, nerve-rattling buzz – is not for everyone. Routine and certainty are not despotic, but can be a framework that, for some, feels comforting.

Adventure requires a certain attitude: the urge to take risks, to embrace change. The thrill of not knowing where you will sleep, each night unveiling a different sky, stars pockmarked in indigo. It is easier to stay than to go.

Adventure suggests off-the-cuffness, taking off without a moment's thought and not looking back. In Maslow's Hierarchy of Needs – a pyramid of human needs, beginning at the bottom with physiological needs (breathing, water, food, shelter), moving upwards to safety, love/belonging and esteem, and finally to self-actualization – adventure ranks close to the top. The ability to travel the globe, undertake a balloon flight or round-the-world race, is a luxury of the highest order. For the poor and working classes, adventure was linked to capital: the only chance of thrill-seeking was an act of self-creation. To volunteer for ship work in exchange for passage, to work as servants to rich travellers or assistants to explorers, to undertake the spadework of building American interstates. In the 1960s, the Irish government offered trips to Australia for fourteen pounds, on the condition that travellers stayed for two years. Too long for a holiday, not enough time to become an exile, but an immersive enough timeline to head for outback sands, or the hot brick of city paths.

When Irishwoman Dervla Murphy was ten, she was gifted an atlas. Transfixed by its maps and borders, she made a vow that one day, she would cycle to India. In 1963, aged thirty-two, she set out from Ireland on a bike (which she

nicknamed Roz). On account of the two wheels, Murphy took only essentials with her – a map, a compass, a 0.25 automatic pistol, various practical items of clothing, a woollen balaclava, leather fur-lined gauntlets, a bar of soap, and a knife – and made her way across Europe. Her medical supplies included one hundred aspirin, 'sunburn cream' (six tubes), paludrine tablets (to ward off malaria) and 'an ounce of potassium permanganate (against snake bite)'. For reading materials, she packed a copy of William Blake's poems and Nehru's history of India.

The route took Murphy through France and Italy, on to the former region of Yugoslavia, Bulgaria, Iran and Afghanistan, and over the Himalayas to Pakistan. She often relied on the hospitality of strangers, some well off, others hugely impoverished, reciprocating their kindness with offers of work. There were obstacles too – broken ribs after being hit with the butt of a rifle, poor diet, and close calls with sexual assault. Murphy's account of the trip, *Full Tilt: Ireland to India with a Bicycle*, was published in 1965, to an Ireland that wouldn't have understood her motivation; that would have liked to chastise her. Her home country of the 1960s would not have thought exploring permissible for women. The walls of a home, or a garden, were the perimeter of most women's lives. Murphy refers to her travels not as adventuring but as 'escapism', and the dual meaning is clear. When she set off on her bike, she was saying goodbye to a country that viewed solo, curious women as dangerous.

Murphy later had a daughter, whom she took with her

on the road. Navigating Baltistan in Pakistan, she bought a retired polo pony to carry the child and their supplies, including sacks of flour, as food was scarce among the local villagers during winter. Three years later, when Rachel was nine, she travelled the first six hundred miles of a journey in Peru with her mother, on a mule. Murphy said people were kinder to her because she had a child with her, and her presence was an opener to conversation and connection. Imagine having a mother as fearless as that? Demonstrating in actions and deeds that women could do anything, and that independence and solitude were to be prized.

Ireland has a long tradition of the *seanachaí* – public storytellers who captivate crowds. Over the centuries, they moved from house to house, telling stories for entertainment, in return for food or drink. Women who were equally adept at the craft told their stories instead at firesides and in kitchens. They were largely forbidden to leave the house and venture into the night, and there was definite disapproval of women who 'ceili'd' (went visiting). The most important storytellers, skilled in complex tales (such as hero tales, and long wonder tales) were predominantly men. Many of their stories were historical, featuring old lore or tales of the land. The stories told by women also featured wanderers, but they themselves were discouraged from wandering far from home. Women had their own complicated tales, committed to memory and retold without notes. Fireside, shawl-wrapped, they recounted them to

other women, and to children. Names like Peig Sayers and Bab Feirtéar emerged, but in the traditional communities – where storytelling was a key form of entertainment – men were primarily at the centre of it. I have learned from editing two all-female anthologies of short stories that there is an assumption made about the content of women's writing. That by virtue of being female, the focus of a writer's gaze will land on subjects supposedly connected to women. Even if they write about love, relationships, families or death, these are deemed lesser, a pocketful of domesticity. Men writing on the same subject are naturally considered the instigators of the great American/Irish/British novel. They are the flag-bearers of the human condition, and no one dares utter the word 'domestic' about their work. Don't we all fall in love? Have families? Die? Fuck? Why the distinction in reverence based on who the teller is?

The adventurer's body is a totem. In tintype photographs, gaunt faces stare at the lens. Eyes give nothing away about the distance crossed, but mud-clogged boots house blistered heels, and fabric layers hide malnutrition and scurvy. Accessorised with a gun, compass or telescope. The closer we get to modernity, the harder it is to guess at the health, gender or endured hardship of an adventurer. Today, emaciation has been replaced by slick sinews, and smears of white sunblock. DIY ensembles in khaki and brown give way to garish neon, as clothing becomes Patagonia'd. What

stands out most about present day photographs is that there are more women in the pictures now.

To set out for the horizon is to head towards its shimmering line. Every time I arrive in a new place, I drop my bags, turn on my heel and begin to walk. There is alchemy in being an outsider, of passing locals who don't know you're not from a place. Blending in with every block, each corner turned. There are choices: use Google or buy an actual map. Go outside, turn left or right, cross traffic junctions past honking cars; stick to the circular path of a small town, or veer to the outskirts, to the sea or fields, to the hinterland. Seek out the borders. In new places, there is a natural gravitation towards the edges. I feel uneasy until I've walked a place. Long journeys can deplete and disorientate, but as soon as I start to wander, I acclimatise. I crave transactions, buying coffee or gum just to hear new accents, to feel unfamiliar currency.

With adventure comes anticipation, a necessary kind of blindness, facing into the unknown miles ahead. The lure of unplanned travel is its own mystery. On the parallel track of discovering new people and paths, there is a part of every traveller waiting to be revealed. Departing requires physically leaving behind an old part of yourself. Perhaps this residue – physical or emotional – is too painful or precious to carry with us and necessitates being discarded. Leaving something familiar behind can be a beacon to light the path back home, a candle in the window. Each footstep on

a journey moves the traveller away from one life and into another, and perhaps the memory of the piece left behind sustains even the weariest nomad. Untethered to us, that part of ourselves that stayed back might have changed. There is always the option of reclaiming it, certainly, but new paths and red hills may have already begun to nudge it out of the frame. It may feel magnetic, at least in the mind, when it has already been displaced by something newer.

On my own, in Malin town, in the very north of Donegal, I experience two very different days. One is bright cyan in every direction, the small village green bathed in rays so hot they almost singe the grass. Out at Five Fingers Strand, a pale spine of sand, there are warning signs not to swim due to dangerous currents, and more warnings for collapsing dunes. The danger in nature is never subtle, even in places of great beauty. 360 degrees of eye-watering brightness. Twenty-four hours later, rain is firing down onto the street in spears. I set out for Malin Head, site of a famous weather station known from the shipping news and sea area forecasts, and the most northerly point on the island of Ireland. Circling the town, there is a harbour, where waves scale up four metres, like a skate park bowl. The wind is strong, orchestrating a shrill howl, but the bulk of the noise is from the fishing boats jostling against each other, port and starboard abutting. The weather station takes a while to find, eventually located because of its visible masts. I'd been expecting a mini fortress, austere and remote, but it's

small and unimposing. My imagination had conjured up something more mysterious, not a modest civic building in a quiet, sea-battered town. There is an old coastguard's office, the arrival point of many long-ago radio conversations, calling out to lost ships on the Atlantic. A place of Morse-coded rescue.

I am a complicated traveller. The lure of it, the distance and the promise of unfamiliar views compel, but often the reality or the shortness of the trip disappoints. It has changed too, since becoming a parent. I always long to ricochet home. I miss my children too much if I'm away for more than a handful of days. Every ticket purchased is a return one. Jumping ship. Stowing away. As Mark Eitzel once sang: *on the highways, there's a million ways, if you want to disappear.* And all of us do, sometimes, to seek out either chaos or calm, to eschew all demands made, to release ourselves from technology, to hide from grief. There is possibility in being lost; of being unlocatable. Of being lifted without ties, like Lilian Bland's glider casting shadows on Carnmoney Hill; Dervla Murphy freewheeling over the Himalayas; Beryl Markham's first glimpse of the coast of Nova Scotia. Adventure operates in the realm of unpredictability: a storm at each crossroads, a cartographic blind spot. But we orient ourselves towards it, bending to the horizon, with all that it offers and conceals.

Twelve Stories of Bodily Autonomy
(for the twelve women a day who left)

Until 2018, it was impossible to talk about the body in Ireland and not discuss abortion. It is especially difficult to avoid it if you are a woman, and write about the body and what it can encounter and endure. The experience of a body, of one person's life, is an existential arc; a solitary set of circumstances affecting just one individual. Before a referendum in 2018 Ireland did not see the individual as a distinct being. Legislation was predicated on one-size-fits-all laws, blanketing all women with the same legal restrictions. Until the results of that referendum came into effect no woman in Ireland could obtain a medical termination, without a very specific and strict set of parameters. In many of these scenarios, the request could still be turned down. Someone else, someone not in the midst of unwanted or crisis pregnancy, decided what was best. If you are not an Irish woman, some context is required here, because these situations don't rear up out of nowhere, a towering mass of control and constraint.

The year 1983 saw a referendum on abortion, the impact of which stretches its tentacles into all subsequent votes and debate on the issue. People voted to insert a clause – the

Eighth Amendment – into the constitution that gave equal right to life to a pregnant mother and her unborn foetus, whether it is a week-old embryo or approaching the twenty-three-week viability mark, making them physically – and legally – umbilical. Think of those early days and weeks, the clump-of-cells stage, the not-a-baby stage. This law impacted the lives of many girls and women. Since 1980, over 150,000 women have left Ireland to seek a termination. The lines between body and womb have become blurred, a vessel inside a vessel. The physical body does not fully belong to its owner if the womb within it contains an unplanned or unwanted pregnancy. There are all kinds of people ready to queue up and remind a woman of that.

July 2017, on a Dublin street, hundreds of people are marching. The demographic is striking: mostly old men and women, who pucker their faces in anger at the pro-choice protesters that line the road. One old man shouts 'Murderers!' at women on the kerbside. The march, organised by an umbrella of anti-abortion groups, is dubbed the 'Rally for Life'. Clutching posters claiming to 'love them both' – mother and foetus – this is a group of people in fear, but not due to the perceived demise of 'the unborn'. And that use of the definitive 'the unborn', which is collective, is important. The anti-choice movement have always equated 'foetus' with 'baby', but use the vagueness of the term 'unborn' politically, a catch-all that doesn't come close to capturing the complicated specifics of each pregnancy.

Amid banners of the Virgin Mary (patron saint of

humanity, not chastity and virginity) and Our Lady of Guadalupe (patron saint of the unborn), they rumble down the street, a collective relic of the past. Their age is not the problem – many contemporaries their age are pro-choice – but they represent a 1950s time capsule of pronouncements on women's lives. For all their religiosity, their lack of compassion for pregnant women is breathtaking. The holiest of holy believers see nothing inappropriate in carrying graphic posters, or telling women that they're going to hell. The crowd is an irate representation of a mindset that opposed contraception for decades, resulting in thousands of crisis pregnancies. Pregnancies that were a collective millstone for generations of young women, burdened with 'illegitimate' infants, shamed for life, and forcibly shipped off to Magdalene laundries and mother-and-baby homes. In these pseudo-prisons, there was commodification of both mother and child. Irish newborns were currency; forcibly removed from bewildered young mothers and adopted or sold. These women were an added source of bounty for nuns and private nursing homes, who worked them to the bone for profit. *Come on in, girls! Here's your overalls, hand over your babies!*

A couple of years ago I attended a literary festival and read some of my work, fiction and non-fiction, that both happened to reference abortion. Afterwards, during the Q&A, another writer on the panel – a smart, funny sometime New Yorker – tells me that I'm a political writer. *I am?* I never

knew this, and in response to my surprise, the writer thinks that I am offended (I'm not). She asks if I reject this idea (I honestly don't), or that the anatomical themes in my writing connect to the politics of the body. They clearly do. No matter what or how you write about the female body – from reproduction to sexuality, illness to motherhood – it is politicised. Women are reduced to the physical: to make it easier to disregard them. To decide, rule and legislate for them. But things are changing. The crowd has swelled; the voices are louder. In the run-up to the referendum campaign, friends go public with stories of abortion, to show the reality and impact the decision had on their lives.

It's 8 May 2018, seventeen days until the referendum on abortion, and I am standing at a stranger's front door. Somewhere inside, a dog is issuing an assembly line of barks. I take a deep breath and wait for the shape of someone to appear behind the frosted glass. I am canvassing ahead of the referendum later this month. Standing at this door, like many I visit tonight, the occupant says that they will be voting Yes. The only hard No is from a young woman who says abortion is murder.

'Even if the mother's life is in danger?' I ask.

'God is good. He will decide,' she replies.

I thank her for her time and move on. On other nights the 'No's are disheartening, even more so if they come from women. Most of my canvass tallies on these nights are

overwhelmingly 'Yes', but none of us want to be complacent about the outcome on 25 May.

In 1992, the news was dominated by the story of a fourteen-year-old Dublin girl, who was pregnant. The situation – a child carrying a child – was frightening and bewildering enough, without the horror that it was the result of rape. A forty-something-year-old man, known to her family, had sexually abused the girl for years. I thought about this girl a lot. Tried to picture her: long hair or short hair? Did she own a pet? Love music? Was her face a smattering of freckles? She was undoubtedly small, but her smallness did not protect her. Faced with an unspeakable situation, she and her parents decided on a termination – but this was Ireland: Catholic, traditional, reactionary Ireland. The rape was reported to the police, and after consultation about a paternity test, her family informed them of the girl's wish to travel to the UK for an abortion. When they departed, police liaised with the Attorney General, who issued an injunction based on the Eighth Amendment. An appeal was lodged with the Supreme Court by the girl's legal team on her behalf, while in London, the teenager told her mother she wanted to take her own life. The court eventually lifted the injunction, permitting the abortion to go ahead, but the stress and trauma of the previous weeks had been too much for the girl and she miscarried.

Later that year, a referendum was held proposing three more amendments to the constitution. I had just turned eighteen

and it was my first chance to vote in any kind of democratic process. The experience was three-dimensional. Walking through it in my head, there were courts and civic buildings, gavels and ballot boxes, a black tick in a white box. People shouting with placards containing images of dead foetuses. On Saturdays in the city centre they collected signatures, flanked by those same placards of what resembled pygmy seahorses, fragments of life. The images are – as they are meant to be – imposing and sinister, inky eyes in boundary-less flesh. But what of this fourteen-year-old girl? Less than a decade and a half older than the foetus. I thought only of her: the fear, the horror of the situation, the silencing of her views. What it's like to be treated as both a sexualised adult and a child, at the mercy of the judiciary. How a system can brutalise and betray its youngest citizens. And that's the difference between this girl and the cells she was carrying. Personhood. Citizenship.

Ireland is scornful of its girl children. The state can and does oppose what a family/a woman/a pregnant person believes is in their best interest. A born girl has no more rights than an unborn foetal one. Within this ongoing patriarchy, there is a belief, even in cases like these, that someone who ends up pregnant has somehow colluded in the outcome. That they *brought it on themselves*. There is only sympathy for that which cannot survive outside a woman's body.

It is May 2018 and one week before the referendum. Every-one is preoccupied and weary. Dublin feels brittle and on

edge. I chair a literary panel in County Longford, and the town is dominated by No posters. The only two Yes ones I see have been defaced. The referendum is not far from any waking thought. Every woman I know cannot sleep. Some confess to jags of spontaneous crying. A relative admits they're voting No, and it feels like a betrayal. We have a long phone conversation, at the end of which they say they've changed their mind. A writer friend overhears a group of twenty-something men talking on a train. One, full of swagger, says he doesn't 'want to give them that', insinuating that women are uppity and asking for too much for wanting to control their bodies. But there are other men too: kind, compassionate ones. The canvass and leaflet drops are full of them, standing alongside us, recognizing what's at stake. We all will it to be 26 May, with the ballot boxes tallied and Ireland finally admitting that the law needs to change.

In 2012, thirty-one-year-old Savita Halappanavar died in Galway after complications arising from a septic miscarriage. The tragic details of the story itself – her youth, her swift decline – shocked everyone. When she pleaded for a termination that would have saved her life, a midwife told her it wasn't possible because 'this is a Catholic country'. Her death was cruel and preventable. It was also a turning point, changing the minds of many who previously wouldn't have considered themselves pro-choice. It prompted protests and galvanised thousands to push on for reform of the

constitution. Savita's name is on everyone's lips in 2018. Her parents urge the country to vote Yes.

As the referendum draws nearer, other healthcare stories begin to emerge. One surfaces about women who underwent routine smear tests under the national CervicalCheck programme. It is thought that over two hundred women were wrongly given the all-clear and seventeen have died. How can we ever think that Irish women's bodies are not ultimately political? A week after the referendum, Irish President Michael D. Higgins invites busloads of women to Áras an Uachtaráin (his presidential home). Women who were survivors of the Magdalene laundries. Imprisoned by the state and religious orders, made to work without pay, shamed for being pregnant, 'fallen' or promiscuous. The history of subjugation for Irish women is a long and complex one, connected to both past and present – the weight of this history bears down hugely on the 2018 referendum.

On the night that the Protection of Life During Pregnancy Act was passed in 2013, I watched the vote inside the Dáil, the lower house of the national parliament. The act allowed for abortion where pregnancy endangers a woman's life, including the risk of suicide, but contained several strict criteria in order for a termination to proceed. On the way in to Leinster House, I passed a large crowd of anti-choice protestors. Strikingly, many were teenage girls and young

women. The very girls who may find themselves squinting at a pregnancy test with a palpitating heart. If their Catholicism is fervent and absolute – abstinence until marriage, no contraception – what would they do if they found themselves with an unplanned pregnancy, whatever the reason? In 2018, post-referendum, I think about those girls, bellowing outside government buildings in their 'Abortion stops a beating heart' T-shirts. Do they still abhor the idea of termination? Would they dutifully persevere with an unwanted pregnancy, even though the law has changed? The groups they represent have always argued that the issue is a moral or religious one. That God and good morality are reasons to forcibly birth a new person. The issue is never seen as being wholly about healthcare, and whenever the anti-choice campaign talks about pregnancies and foetuses, the weight of discussion tips towards the unborn, not to a woman's health. Her body is secondary.

There is always the historical argument. That Ireland was a very different place in the past, even though the Eighth Amendment was only introduced a quarter of a century ago, a reach-out-and-touch-it amount of time. The years either side of it saw teenager Ann Lovett dying at a grotto while giving birth; Eileen Flynn sacked from a teaching job because she was pregnant by – but not married to – the father; and the Kerry Babies case, which accused Joanne Hayes of murdering her stillborn child (partly because she was also unmarried). To copper fasten this fear of women, and to resolutely keep them in check, our constitution still contains a clause, Article 41.2.1, about the place of women

in the home. ('The State recognises that by her life within the home, a woman gives to the State a support without which the common good cannot be achieved', and 'The State shall, therefore, endeavour to ensure that mothers shall not be obliged by economic necessity to engage in labour to the neglect of their duties in the home.' There is talk of a referendum to remove it.) History can be blamed for cumulative acts, but in inching forward it is taken for granted that this movement will be towards progress. Towards more democratic ends, more socially liberal ideas, which have traditionally advanced the cause of women's lives. Ireland has changed – and is changing – but this does not undo the damage and trauma that has been inflicted on women.

In spring 2018 I drive my children to school and they ask about the No posters that hang on every lamppost. About why people are talking about murdering babies. My children – who are young enough that they still haven't asked where babies actually come from – should not have to see these disturbing images. I'm caught between the grimness of the conversation and not wanting to condescend. I explain about the lies on the posters, about how sad and complicated it is for women. I explain that this vote is about choice and health, and not making decisions for other people. My daughter makes a sign to hang in our front window: *If you're voting No, go away!* At a local family day in a park, my son encounters a man who is handing out No badges and tells him that he should be voting Yes instead. My children, who

were once foetal images on a screen, are now full of opinions and questions. Although this is all complex, they are listening and they understand.

The many legal cases that have been taken in the name of abortion add up. X, C, D, another D, A, B, Y, NP. We have turned women into letters. This has been done as a measure of privacy, especially as some are minors, but it is also an act of erasure. Women alphabetised and, as a result, anonymised. It is easier for those opposed to the wishes of these women to negate them if the reality of their lives is represented merely as a letter. X, C and Miss D were minors – all victims of rape – and the cases were heard in camera. D was a woman carrying a foetus with a fatal abnormality. Ms Y was an asylum seeker raped in her home country. When she was refused an abortion, and told her pregnancy was too advanced, she went on hunger strike. The baby was forcibly delivered by C-section at twenty-five weeks. The woman, who later took an action for trespass, negligence, and assault and battery, was treated as an incubator. NP, a pregnant mother of young children, suffered a massive neural injury and was kept alive on life support against her family's wishes. The hospital, fearful of breaching the constitution, felt they had no option but to keep her alive artificially until the foetus was delivered. Her parents and partner disagreed, and the story played out in the news, with gruesome and distressing detail about her physical condition. Women who didn't – or couldn't – offer consent to their situations were treated as grotesque growth pods. A Gileadian *Handmaid's Tale* from which Irish women couldn't seem to wake. To talk about the body in Ireland, to

write of it, is to confront this theft of autonomy. To examine who controls it, or has the right to it, and why there is no comparable legislation that affects men.

Two days after my first canvass, I go to the oncology ward of a large Dublin hospital for a regular check-up, to ensure that my past leukaemia has not returned. I sit in front of my consultant and ask if he remembers how there was a birth control mishap during my treatment. As well as being possessed of life-saving qualities, the main drug I took at the time came with warnings that it caused severe foetal damage. My consultant, a kind, smart man who has all the warmth lacking in many doctors I've encountered, listened with concern back then, and prescribed a morning-after pill for my predicament. I ask him today if he remembers what he said to me, when, ill and fearful, I questioned what would have happened if the pill didn't work and I found out I was pregnant. Fifteen years later, he recalls his exact words, without missing a beat: 'Well, we'd have a conversation.' I wonder if this is due to the complexity of my case, or because he's had this 'conversation' with so many of his female patients?

I know that the law back then was impossible to navigate. That for a cancer patient, recovery – not pregnancy – is the priority. His hands were completely tied by the reality of the legislation, even though we both knew that being pregnant was only marginally worse for my health than being dead. I don't like to think about the 'what if' for too long.

To consider whether I'd have been well enough to make the trip to London or Liverpool. Or if the law would have forbidden me to travel, and concluded that my treatment should have stopped, to protect the pregnancy, with fatal consequences for me.

Reproductive health is about autonomy, agency, choice and being heard. It is also about money, class, access and privilege. Ireland's history – for women – is the history of our bodies. The goal for the future, at its most basic and unprepossessing, is equality, respect, reproductive control and equal pay. Change has been hard won. It has been set in motion because of women who speak up, protest, march, lobby and put themselves out there. Shifting their stories from private spaces to public spotlights. On polling day, I think of all those women as I walk to cast my vote with my children. It is hot, the sun benevolent, and I try not to assume that this is pathetic fallacy. Outside I take a photograph of my daughter beside the polling station sign, her body showing its own traces of change. I want to record this moment in the hope that this is the last day that her reproductive rights will be out of her control. The sun catches her hair, and I see all the ways her life will be different. She takes my hand, and we walk into the cool air of the hall, to change the future.

Second Mother

They say it started with blackouts. Falling like a felled tree in unforested places. Several times, outside the strip of shops she lives near. The locals all know her, so whenever it happens, they run to my brother's house and hammer at his door.

'She's had a fall.'

And there she is, all four feet eleven inches, prone on the ground. In her portable shopping cart we find packets of biscuits and a day-old dinner still on the plate, vegetables congealing while we wait for the ambulance.

It's fortunate that this happened in public. If she'd been at home, it could have been in the shower, or on the stairs. Crumpled on the floor by her single bed, unfound. But it's not actually lucky at all. She's done all the right things: worked until retirement, voraciously ploughed through books, squinted at word-search puzzles under her bedside lamp. The stats ensnared her. Ushered her in, and she sat, docile, not comprehending what was happening. Memories became segregated from the parts of her that occasionally still note the time, or recognise a famous face in the

newspapers we bring. The neural path between her eyes and brain is now choked with weeds.

The blackouts weren't the start of it. We know that. There's a different kind of blackness in her brain, one that started with circular conversations, asking the barest number of sociable questions. Enough to be polite. As she sat at our kitchen table for dinner over the weeks, I saw her moving away from us. A grainy facsimile of who she used to be. My children are always patient when she asks, 'Were you in school today?' Sometimes it's the sixth time in half an hour. Sometimes it is Saturday.

No one has an auntie like Terry. This is often said, without resentment, by my other aunts. They all recognise the goodness in her. When I tell people about her, I often say that she is my second mother. She's my godmother too. My middle name is her name, and I gave it to my daughter as her middle name.

Terry did all the things you're meant to do with kids who adore you – bake, cook, paint, craft. She indulged my random fashion phases with nuanced, well-chosen clothes and accessories. My first books were gifts from her: faux-leather hardbacks and abridged versions of the classics. Later, we'd scour second-hand shops together for copies of Agatha Christie and Ngaio Marsh. I don't say it lightly, but she is the reason I'm a reader and a writer. Her constant, gentle nudges towards the written word are an unrepayable debt.

Her tininess is distinctive. Compact, but fierce. She wears Scholl shoes (size three) and sheer scarves. On nights out she favours wrap dresses with high heels, bringing her in over the five-foot mark. Frosted pink lipsticks, a shimmer of powder over her freckles. Her tipple is always white wine, or vodka and 7 Up. Or it used to be. The conflict of tenses, of trying not to talk about her in the past tense. The dresses are packed away. She wears fleeces and slippers now. Her hair is longer than it's ever been. Blue eyes curtained by the glassy sheen of age.

When she's had her fourth, fifth, maybe sixth fall on the street, an ambulance brings her to hospital. Soon, the Irish healthcare system needs her bed for someone else and she is moved to a dementia ward in a Dickensian building. On the patient whiteboard I spot the name of a prominent poet, but don't ever see him. People disappear here, into themselves, into the dado-railed wards and lightless corners.

Across from my aunt is a woman who shouts in urgent, iambic bursts. She sidles up to me and hisses, 'Don't talk to her! She wants to tell everyone your business!' Another patient carries a doll everywhere, stroking its hair, while her husband sits at her bedside. These women, with children of their own, with lives and achievements behind them, would not recognise themselves as they are now.

I fear losing my mind more than I do dying. I'd take a shark attack and falling from a height and being stabbed before I'd take my mind being hijacked and replaced with clouds. I would take another round of cancer over

untreatable dementia. The toxic silt of chemotherapy sludging through veins. I'd take that over my family watching my personality, my memory, me drift – unreachable – to the bottom of some sea. Anchored in the dark, the weight of all that water. Memory punctured, slowly deflating. *Where did you go?*

There were busy decades in her life before all of this. Before illness stole her from us. In the 1950s there were factories for working-class Crumlin teenagers, which threw open their doors to girls like Terry who left school at fourteen. Cosmetics makers and confectioners; clothing companies with rows of young girls hunched over sewing machines. Terry worked for all of them. Her father joined other Irish emigrants catching the boat to Holyhead, and was gone for years. In her early twenties, her mother died – my father was just eleven. As the only girl in the family, the role of primary caregiver fell to her. No matter that she had a full-time job and a life to lead.

Generations of women have, by virtue of their gender, been made accidental matriarchs, even if they've never given birth. A kind of motherhood was thrust upon Terry – caring for younger siblings and elderly relatives. Because she was a woman she was presumed to be a de facto carer: a sheet-washer and bed-changer. Another of the red-tape hecklers who argue with local authorities about medical grants; a chauffeur to hospital appointments. For these women, there must be a ceding of something. Life must be pared back, but what to give up? Love, art or independence?

It's also more likely for women than men to lose their memory in old age. Most people use the terms 'dementia' and 'Alzheimer's' interchangeably, according to a doctor I ask, but Alzheimer's accounts for only 50–75 per cent of all dementia cases. 'There is no narrower figure than that 25 per cent range,' he says – it's a hard disease to diagnose.

There are theories, but no definitive reasons why women are more affected. Researchers at Stanford University believe that carrying a copy of the ApoE4 gene increases the risk for women because of how it interacts with oestrogen. It's a sort of hormonal fait accompli. Another basic, uncomplicated factor is age and life expectancy. Women live longer than men, and are overtaken by Alzheimer's.

A nurse tells me about another gender impact. Women, so often the default carers, are more likely to nurse their relatives at home until they can't cope. Men, especially those of today's elderly generation, weren't raised as carers or cooks. They don't know how to look after their wives so they sign them into nursing homes as soon as the illness progresses.

How do we know when it starts? How to differentiate dementia from climbing the stairs to retrieve something, but being unable to remember what? Do we declare an onset of Alzheimer's after forgetting a famous face (*you know, what's his name?*). It's a dim boundary, but at some point our neurons struggle to regroup. The cortex and hippocampus are irrevocably changed. In memory loss, there is already death. Cells die and each one is a divesting of some part of

the past. The cortex shrinks where the cells used to be. The spaces in between expand. Islands in the sea of the mind. An archipelago of the former self.

Terry never married, and there were never, in my lifetime, any partners. I think this is a situation she was content with, but I can't be certain. She didn't resemble the societal caricatures of women like her. The maiden aunt, or spinster, living a *Lolly Willowes* life. Her friends were her social lifeline, and they took pilgrimages to Knock together, organised by the local church. Holy water bottles filled with vodka, giggling on the coach home. She worked for a big drinks company and there was always booze in her house, even though she was a late convert to alcohol. I visited her regularly in my late teens and sometimes we'd sip wine by the fire, or out in the garden in summer. I'd try to spool back through her life, testing the ice of what I could ask about. There were some men, tentative dates, but 'They always annoyed me,' she laughed. Our closeness was a comfortable one, without judgement, and as we talked, it became clear that she had never been physical with anyone. We didn't make it as far as whether she regretted this, but I absorbed it. When I think of it, even now, I feel it like a shove, her loneliness.

Still, she has a small but close band of friends, and is always surrounded by family. No matter what the company, she is indefatigably herself. Wry, wise, funny. Strong and self-sufficient, she asks nothing of anyone. Class or the universally observed Catholicism of the day may have

instructed her not to demand too much. Occasionally I heard her put on a posh voice, often used in deference to actual posh people.

There is her laughter, a once-frequent shriek of delight, but it is rare these days. Laughing at a joke means you understand. There is a moment of cognisance: *I see what you did there.* Back at home after her stint in the dementia ward, she's replaced books with TV. One afternoon it's blaring a show about fishing and I ask her about a trip to Rimini she took with her best friend. There was sunburn and men chatted them up as they sipped Limoncello. When she tells this story, I picture her Hepburn-like in shades and a head-scarf, driving along a cliff road. I wish I'd known her then, her younger self; so much responsibility at home but free of it for a few days on the Italian coast.

Every week we invite her for dinner, and slowly the words start to drain out of her. Vocabulary becomes an unfamiliar tool, as if she's handling a wrench. There was always easy conversation and discussion, but now the words become flotsam, just out of her reach, hard to snag. Lining them up is so much effort that she can sit through pasta and salads, sometimes as far as dessert, completely wordless. Her friendships, save for one or two, start to get left behind. She refuses to travel or attend family events. She stops going to Mass, and then she misses a close neighbour's funeral. The self she knew inches away from her, and she begins to abandon her own life. I think of a line from *Lolly Willowes*: 'It is best as one grows older to strip oneself of possessions,

to shed oneself downward like a tree, to be almost wholly earth before one dies.'

It is innate, this fear of unravelling. We might not see the car as we step off the kerb, or feel the bullet's initial bite into skin, but we know something has happened. We know there will be blood. It's the stealth of Alzheimer's that's so cruel. In most deaths – even a drawn-out, throat-rattling, morphine-addled demise – we remain ourselves. Medicated, intubated, but us. This illness transforms only the interior. The body becomes less a prison than an aquarium. Visitors, the people you love, looking in, regarding the body-snatched version of your mind. You, looking out, your whole worldview distorted as if by water and that thick, impermeable membrane. You now, and you as you once were, on separate sides of the glass.

It eventually becomes clear, though we admit it with devastation, that Terry needs full-time care. My parents scour the city for a nursing home that is close to where we all live. They find a clean, comfortable place where the staff are kind and there is a garden. On the first day, when she is transferred from the hospital, she refuses to go in, screaming in front of the building, blaming my father, much to his distress. They have done so much for her, but are getting older themselves. They cannot take her on.

In the first weeks she keeps to herself, and rarely leaves her shared room. In the other bed is a woman who is never awake. The only sound is the pump filling her pressure

mattress, air spreading under her frail limbs. On the wall there is a framed photo of me at a book awards ceremony. One winter day, when the light has gone by late afternoon, she gestures to it, eyes trained on my daughter, and says: 'Look! There's . . .' And even though I am there beside her, my name is a mystery. A collapsed dune, thousands of grains seeping from the hole in her memory.

The house in the working-class area where she grew up was built in the 1930s, and the back gardens are long rectangles. As I've grown, so has the garden, the lawn now shaded by the height of the trees. I see her with gloves and secateurs, always planting and sowing, deadheading rotted petals. Yellow snapdragons and silken tea roses. Purple African daisies that she insists on calling 'union flowers' because they close their petals at sundown. In summer the air hangs with the perfume of sweet pea in pink and mauve (a word that instantly makes me think of her). And there is lavender – bushes of it – heady for only a couple of months a year. A row of plum trees sprout, their close planting like upturned ribs, with two makeshift swings on the branches. We'd push ourselves as high as we could, gripping the greasy twine, learning to tuck our legs under on the descent to build momentum. Her happiest moments were spent here, taming the overgrown honeysuckle with string, battling a relentless buddleia.

In the summer we sit in the back garden of the nursing home, and she tells me – conspiratorially – that there's a secret door in the wall. The first time I'm curious, but we

find only a laundry room, the rumble of dryers, the smell of steam and artificial meadows. I ask about the flowers in the raised beds, but the names have long left her. Each time we pass, she insists that my father planted them (he didn't).

I know her tricks now. The ones she uses when she is trying to hide the fact that she and her memory are at odds. She feigns deafness sometimes – 'What?' – which buys her a couple of moments to process a question. Mostly, she shrugs, as if she doesn't care, but I see the shadow pass over her face. The struggle. She never talks about what is happening, but I know that she knows. After a particularly difficult attempt at telling a story, she stops, and says with a haltingness that takes the air out of the room: 'Sometimes . . . the words . . . I just can't find them.'

We rarely ask people their stories, the small moments and big joys of their lives. Their regrets. We don't until it's too late. Until we are sipping whiskey from the wrong size glass at someone's wake. She is still here and I don't know how to ask, *Did you ever fall in love?* It's too big a question now, too impertinent to pose when her brain struggles with, 'Do you want me to turn the TV down?'

My daughter makes signs for Terry's door. One declares her the best auntie in the world. They're a statement of ownership – a flag staked on a mountaintop – but their main function, on this small, straight corridor of bleached floors, is that she can tell which room is hers. There are lots of optional activities – art, crafts and social events – but she refuses to get involved. She used to paint, and on the

sitting-room wall of my childhood I remember a framed seascape. When she retired, I bought her new brushes, fat tubes of oils and small canvases, hoping she'd take up art again. My father found them in a wardrobe, unopened, while packing up some of her things to move her to the home.

When I see her now there is still a flicker of recognition, but it dims a little more every time. One weekend I arrive to her laughing with another patient. Arms linked, we walk back to her bedroom and I ask about the new pal. There is nothing on her face to say she is being evasive. Instead, she has already forgotten the moment of them laughing, and cannot tell me her name. This annihilation of moments that have literally just happened is new.

This is not the worst it could be. Others tell me stories: friends caring for parents, their collective faces carry the same resignation. The woman who keeps being found at bus stops because she's going to visit her siblings – who all live in England; a mother who hits her adult daughter because she thinks she's her husband's new girlfriend; a man who has never been to war talking about life in the trenches. Terry's manifestation is quiet withdrawal, repetition, a feeling that something is not quite right.

By spring, her body starts to draw level with her mind in terms of deterioration. There is double incontinence, her appetite diminishes. A cup of tea dangles at a dangerous angle in her freckled hand. The sentences become even more half-formed, the lexical equivalent of a ghost estate. She walks me to the door, and I see the stoop, the tilting

of her frame, the slack arm. A nurse notices too, and later they call to say she's in hospital after a mini stroke. But she is awake and here and still trying to shuffle words into the right order. Her kind face, once full of hundreds of stories, now only wants to sleep.

One of us is in a boat, the other on the land. She is so still these days, so quiet, that it must be her up there on the clifftop looking down. I am the traveller departing, tilting on the riptide. The house and garden, once so full of her, are quiet, rose petals falling, plums still clotting on the branches every autumn. She lives two kilometres away from her old life, almost a straight line from the house. She is in her eightieth year in a quiet room, unseeing the news, unreading the books on her bedside locker, but still smiling whenever someone she thinks she knows walks in.

In April, there is another mini stroke, a declaration of what's to come: more seizures, rocketing blood pressure, the total evaporation of speech. Her life pinballs between nursing home and hospital. She begins to refuse food. I offer her yoghurt and creamed rice on a spoon, and she seals her mouth into a tight line. A hospice nurse arrives to insert a morphine pump, talking quietly about phases of death, about 'active' dying. And there it is. We know now that she will leave us in a handful of days.

In her room the staff set up a mini altar: a white statue of the Virgin Mary, holy water and candles (electric, for safety). To secularise this, I add a book and flowers from her

garden, London pride and African daisies. It's too early for lavender, so I bring essential oil instead, dropping it onto her pillow, mixing it with hand cream to rub into the ridges of her veins.

Over the weekend her breathing becomes apnoeic, deeply drawn from the well of her lungs. A juddering sound, then nothing for up to twenty-five seconds. I stare at her unrising chest, watching the pulse in her neck, a weakening beacon under the skin. The nurses say she can still hear, so I read her *The Clocks* by Agatha Christie. Staff appear occasionally, making checks, offering tea. Her height was one source of her self-deprecation – 'Good goods in small parcels,' she'd say – and now she looks even tinier, lost under the sheets.

Death has a particular smell. A finality and staleness. It resembles an unaired house, or the space under the stairs. Her room has never felt so small. There is so much waiting. Time is static, but creeping on, measured by her worsening breath. By Sunday, after midnight, it is loud, an amplified snore. This battling with her own body is hard to watch. My father and I sit by the fake candles. More morphine to ease her distress. The beacon in her neck slows, her skin starts to cool. Leaving the home on that last night, I kiss her hands. *You were so important*, I tell her. *You were so loved.*

Terry dies in the early hours of 1 May. It is also known as May Day or Beltane, sometimes called *Lá Buidhe Bealtaine*, 'the bright yellow day'. On May Day, yellow flowers celebrate the start of summer because they resemble fire, and are placed on the doors and windowsills of homes for

good luck. On Terry's coffin we place yellow lilies alongside paintbrushes, books, and a framed black-and-white photo of her and her best friend in a sixties mini dress and sunglasses. A time when her life still had so much possibility, her mind carefree, hungry to know about the world. Beltane is half-way between spring equinox and summer solstice. In the calendar, it is the opposite festival to Samhain, symbolic of endings, of dark months and the harvest; while Halloween overlaps the worlds of the living and the dead. Dementia left Terry halfway between her recent self and the person we had always known and loved.

Author Sylvia Townsend Warner also died on 1 May, thirty-nine years earlier. In creating *Lolly Willowes*, Townsend Warner gave literature one of its most famous female char-acters. A woman who obliterated the idea of what a woman alone could be, a woman who revelled in her independence and found solace in nature. And a character who demands the question of all of us: what constitutes a self-determined life, a life well lived? The way Terry lived hers – being vital, real and exactly who she was – impacted hugely on my brothers and me. We were not related to her by blood – and that's a longer, complicated story – but felt she was in our DNA. Her skin was ours, our hearts were hers.

Days as dark as when she died – numb ones full of shock – are rare. There was another some years back, when I was in hospital with a lung clot. My husband had just left after hours of waiting and Terry was there when the really bad news came. A completely unexpected diagnosis

of aggressive leukaemia. We stared at each other, baffled, distraught. It was the only time I ever saw her cry. 'What'll I do without you?' she said, finally. And this is what I have been asking myself since that May Monday.

It is finally summer, and every bloom in Terry's garden is thriving in the sun. On what would have been her eightieth birthday, we spread her ashes. Greyness falling on the open petals, on rose thorns, on the daisies and clover that have encroached since she stopped tending the lawn, and on the purple spears of lavender swaying in the breeze.

A Non-Letter to My Daughter
(named for a warrior queen)

I write this to you, daughter,
Place these words in your hands,
To help you understand
The way the world will be
Because you are a girl.

That chemistry and biology
Have colluded
In your cells.
That to some
your being is a reason
to chasten,
your body a warning
A tocsin
How X, or double X, marks the spot.
The target for what you cannot
Do, or say or be.

See, I write this to you, daughter,
But I could write this
To my son

But as Joe Jackson sang
It's different for girls.

Your girlness, that unfairness
Is an ongoing thing – that the world
When it tilts and spins – will push you away
And you'll be weighed up on the way you look
Your size and your face
The space you take up
And if you put out or put up with things

Don't feel you have to smile
just because
Someone tells you to.
To *cheer up love,*
To *hey I'm talking to you,*
To *hey, stuck-up bitch.*

Don't change if you don't want to
But change is a leap into the light
Chrysalis, hit and miss
I realise that *don't* is not a word
we should direct at girls.

Your lungs were the last part
of you to work
when you were born too early,
but you sing, and you sing and you sing.
And if someone scorns the notes that you *bend,*
the songs that you send out into the world
Sing louder. Be bold.

238 — Sinéad Gleeson

Don't hold in your porcelain belly,
skin smooth as an egg,
like the ones you make me boil,
and only eat the yellow from.

Hold on to your good friends,
Those bright boys and girls,
Who light up when your name is mentioned,

Don't try to make that girl like you
Don't fret when you are excluded

Jettison bad cargo
Folk who talk out of the side of their mouth,
Those who go out of their way to avoid your good news,
who flash facsimile smiles when the world smiles on you,
The people who are too afraid to try to do
what you will one day do.

Be a wanderer, a nomad
A rover, a roamer
Sail all the seas,
Be guided by stars
Climb trees, talk to birds,
Sow seeds wherever you go
Leave footprints in every city
Kiss and be kissed.

Find your sisters,
From other mothers
Your Amazons and witches

A Non-Letter to My Daughter — 239

Believe in gods and monsters
If you want to

Swim in lakes and rivers
In slivers of reeds
The green hum of water
In your ears.

Embrace heights,
Climb higher
Cliffs and bridges are not to be feared
Your mountain breath
Can withstand it all

Grow flowers and wander
Amid pollen and petals
Never settle for what you don't want or love

Weigh the world up,
like a bag of water
Try to guess the weight of the life you want.

Your peacock swoon
And tiger spine
Oh, your sea glass eyes

Don't be afraid,
Don't be fearful.
They are not the same thing.

Don't worry about what will happen next.

Assume there is goodness all around
unless there is not,
and even then, be the goodness.

Constellations key

andromeda

Blue Hills and Chalk Bones

coma berenices

Hair

crater

60,000 Miles...

horologium

Our Mutual Friend

gemini

*On the Atomic Nature
of Trimesters*

hydra

Panopticon

scorpio

The Moons of Motherhood

aries

The Haunted Haunting Women

the chameleon

Where Does It hurt?

pictor

*A Wound Gives Off
Its Own Light*

circinus

The Adventure Narrative

the plough

*Twelve Stories of
Bodily Autonomy*

cancer

Second Mother

volpecula

A Non-Letter to My Daughter

Acknowledgements

A book is not the work of one person and I am grateful to various people who helped *Constellations* on its way.

I am lucky to have not one, but two editors at Picador: the brilliant Paul Baggaley, a champion from the moment he read it, and Kishani Widyaratna for her fierce intelligence and the care and attention she gave this book.

To my agent Peter Straus, who took me on based on three essays and has been unwavering in his support.

To Cormac Kinsella – not everyone gets to have a good friend as their publicist.

To the editors who published my essays: Melissa Harrison, Kevin Barry and Olivia Smith of *Winter Papers*, Claire Hennessy, Eimear Ryan and Laura Jane Cassidy at *Banshee*, Susan Tomaselli at *Gorse*, Paul Scraton at *Elsewhere* and Maeve Mulrennan, who commissioned a version of 'Panopticon' for a group exhibition at Galway Arts Centre. I'm particularly grateful to Luke Neima at *Granta*.

To the Arts Council for a bursary that allowed me a short break from freelance work to focus on writing.

To the Tyrone Guthrie Centre, Annaghmakerrig, which offers immersion and headspace to all kinds of artists, and was vital for me.

To people who offered help or advice on everything from dementia to DNA, and other providers of good deeds: Ronan Kavanagh, Aoife McLysaght, the Irish Blood Transfusion Service, the V&A Museum, Louise Dredge, Zoë Comyns.

To the good doctors: Professor Patricia Crowley, Dr Miriam Carey and Professor Paul Browne and all who work in haematology and in the Burkitt Unit in St James' Hospital (please consider donating blood and platelets).

To Anne Enright, for her friendship, wit and encouragement.

To writer friends who offered advice, chats and solace: Lucy Caldwell, Patrick deWitt, Elaine Feeney, Sarah Maria Griffin, Elizabeth Rose Murray, Doireann Ní Ghríofa, Liz Nugent, Mark O'Connell, Derek O'Connor, Max Porter and Anakana Schofield.

Special thanks to the way-back-when writers who read my work and encouraged me when I wasn't writing, or was too afraid to: Colm Keegan, Peter Murphy and June Caldwell.

Extra thanks to Siobhán Mannion, the kind of first reader every writer craves.

To my parents, Maura and Joe for their lifelong support, especially during all those hospital appointments; to my wonderful brothers Martin and Colin, and to Claire and Daniel.

To Neva Elliott, the sister I never had, but always wanted – and a best friend beyond equal.

To Iarla and Maebh – my own little stars, I'm so lucky to have you.

And to Stephen Shannon, for so much love, support, encouragement, laughs, music and more than I can ever say.

Permissions acknowledgements

Anne Carson, 'A Wound Gives Off Its Own Light', from *The Beauty of the Husband*.

Nick Cave, from 'Into My Arms', published by Mute Song Limited, on *The Boatman's Call*, 1997.

Hélène Cixous, from *The Laugh of the Medusa*, from *Signs: Journal of Women in Culture and Society* 1, No. 4 (Summer, 1976): University of Chicago Press, pp. 875–93.

Barbara Hepworth, from Sophie Bowness (ed.), *Barbara Hepworth: Writings and Conversations*, Tate Publishing, 2015. Writings by Barbara Hepworth © Bowness.

Kirstin Hersh, from 'Hips and Makers', on *Hips and Makers*, 1994.

Maggie Nelson, from *The Argonauts*, Graywolf Press, 2015, and Melville House, 2016.

Emer O'Toole, from *Girls Will Be Girls: Dressing Up, Playing Parts and Daring to Act Differently*, Orion, 2015.

Jo Spence, from *Cancer Shock*, courtesy of the Richard Saltoun Gallery, London.

Ocean Vuong, from 'Immigrant Haibun', *Night Sky with Exit Wounds*, Jonathan Cape, 2017.